Blake Nevius

COOPER'S LANDSCAPES

An Essay on the Picturesque Vision

University of California Press

Berkeley, Los Angeles, London

ABOUT

QUANTUM

BOOKS

QUANTUM, THE UNIT OF
EMITTED ENERGY. A QUANTUM
BOOK IS A SHORT STUDY
DISTINCTIVE FOR THE AUTHOR'S
ABILITY TO OFFER A RICHNESS OF
DETAIL AND INSIGHT WITHIN
ABOUT ONE HUNDRED PAGES
OF PRINT. SHORT ENOUGH TO BE
READ IN AN EVENING AND
SIGNIFICANT ENOUGH
TO BE A BOOK.

COOPER'S LANDSCAPES

University of California Press
Berkeley and Los Angeles, California

University of California Press, Ltd.
London, England

Copyright © 1976, by
The Regents of the University of California

ISBN 0-520-02751-5
Library of Congress Catalog Card Number: 74-77730
Printed in the United States of America

Contents

Preface

Francis Parkman once wrote of Cooper's "pictures": "Their virtue consists in their fidelity, in the strength with which they impress themselves on the mind, and the strange tenacity with which they cling to the memory. For our own part, it was many years since we had turned the pages of Cooper, but still we were haunted by the images which his spell had evoked. . . ."[1] My own interest in Cooper's landscapes began similarly with the realization that they persisted vividly in my memory, as indeed they must in every reader's, long after the makeshift romantic plots and most of the characters had faded. It began in fact with the discovery (or such it seemed to me) that Cooper, in an effort to assist the reader's vision, habitually used a device similar to the commanding center in landscape painting. There the matter might have rested, except that on further investigation it became apparent that none of Cooper's American contemporaries, including his critics and illustrators, seemed aware of what he was doing, or at least permitted themselves to "see" as he was trying to persuade them to see. (See Appendix: Cooper and His Illustrators.) The most extravagant tribute came from abroad. Balzac, in his well-known remarks on Cooper's achievement

[1] Francis Parkman, "The Works of James Fenimore Cooper," *North American Review* 64 (1852): 149.

in "idealizing the magnificent landscapes of America," urged his fellow prose writers to follow the American romancer's example: "Never did typographed language [*l'écriture typographiée*] approach so closely to painting. This is the school that literary landscape-painters ought to study; all the secrets of the art are here."[2] But what those secrets are Balzac does not attempt to explain.

Recent scholarship has begun to explore this aspect of Cooper's art. In the wake of suggestions by certain historians of American art, the discussion of the relationship of Cooper's landscapes to those of early nineteenth-century American romantic painters was initiated in the 1950s in pioneer essays by Howard Mumford Jones, James F. Beard, and Donald A. Ringe; and it has been amplified considerably by the appearance of Professor Ringe's *The Pictorial Mode: Space and Time in the Art of Bryant, Irving, and Cooper* (1971) and James T. Callow's *Kindred Spirits: Knickerbocker Writers and American Artists, 1807–1855* (1967). In all candor, I should say that it was a certain dissatisfaction with the current and only partially helpful analogy between Cooper's landscapes and those of the Hudson River School of painters that led me to attempt a closer definition of Cooper's visual imagination—or at least one launched from a different perspective—because it appeared to me that the analogy reflected merely a parallel development between Cooper's art and that of the Hudson River School without adequately taking into account their possibly similar aesthetic origins. Another of my motives has been to modify the more metaphysical interpretations of Cooper's landscapes, with their emphasis on his use of the sublime, and to redress the balance by insisting that for a variety of reasons his interest

[2] Katherine Prescott Wormeley, transl., *The Personal Opinions of Honoré de Balzac* (Boston: Little Brown, 1899), p. 116.

was solicited more naturally and characteristically and, for the purposes of his forest romances at least, more appropriately by the picturesque.

I have also read with interest John F. Lynen's recent *The Design of the Present* (1969), which argues the case for landscape as the paramount element in Cooper's fiction by pointing out that the characters' lack of complexity and development requires that their reality be tested by their response to nature rather than by the action, and which indeed pushes its thesis to the limit by concluding that "the main purpose of Cooper's derring-do is to serve as the means of creating visual panoramas rather than a coherent story."[3] Although I regard this last as an overstatement, I have a sneaking sympathy for it, as for any theory that finds in other elements of Cooper's art a compensation for the weakness of his plots, and my own emphasis in the essay that follows may for some readers lend credence to Professor Lynen's assertion. What I do not find in his account of Cooper's transactions with the American landscape is any attempt to identify the distinguishing qualities of Cooper's visual imagination or to explain their origins. I think that we have customarily taken too parochial a view of Cooper's knowledge of aesthetics, neglecting his interest in the twin arts of landscape painting and gardening as they developed in Europe and America, and that it is time to examine his aesthetic education from a somewhat different perspective.

The development of my argument may be summarized very briefly. In the first chapter I am concerned mainly with Cooper's characteristic mode of selecting and organizing the elements in his physical settings, as demonstrated in such early romances as *The Last of the Mohicans*, *The Prairie*, and

[3] John F. Lynen, *The Design of the Present: Essays on Time and Form in American Literature* (New Haven: Yale Univ. Press, 1969), p. 179.

The Wept of Wish-ton-Wish, and, secondarily, with his early use of the prospect view as a technical device in both his fictional and non-fictional writings. The second chapter draws largely on Cooper's travel books to indicate how decisively his aesthetic education was advanced during his seven years' residence in Europe and how thoroughly, in particular, he mastered the attitudes and vocabulary of the picturesque convention. The third chapter deals with his early and continuing interest in the art of landscape gardening, its manifestations in such works as *The Pioneers* and the Littlepage trilogy, and especially with the possiblities that this emphasis offers in solving the structural and thematic problems of one of Cooper's later and in some ways most perplexing romances, *Wyandotté*, or *The Hutted Knoll*. In the fourth chapter I pursue further the influence of the picturesque convention and the principles of landscape gardening on Cooper's later fiction and then, calling on E. M. Gombrich's theory of perception as developed in *Art and Illusion*, try to demonstrate how Cooper's European experience altered his mode of viewing and representing the American landscape—more particularly, how his treatment of landscape is in certain instances modified by the dominance of a particular schema acquired abroad.

Having indicated briefly what this essay attempts to do, let me say what it does not attempt to do and by implication what I think it should not attempt to do. I am interested in the development of Cooper's visual imagination and the ways in which he made it serve the purposes of narrative. My emphasis does not lend itself to a reordering of the priorities in the study of his fiction or, by extension, to an estimate of his social and political philosophy different from that established by earlier scholarship and criticism. Where my approach suggested the possibility of a new reading, as in the case of *Wyandotté*, I have taken that direction, but I am not prepared to use my findings as a point of departure for a reinterpreta-

tion of Cooper's thought as expressed in the overall range of
his writings. My general interest is in the relation of literature
to the sister arts, and it is only within the context of Cooper's
aesthetic development that I wish to claim originality for my
conclusions. Jean Seznec, in a 1972 essay, "Art and Literature:
A Plea for Humility," remarked that twenty years ago he had
"suggested that sweeping considerations could be profitably
replaced, or supplemented, by modest monographs, based on
sure data, and free from any fallacious terminology," and ex-
pressed his gratification on having his motion seconded
recently by an unidentified younger critic, who wrote: "The
time of brilliant generalizations seems to be passing; the
studies on art and literature, while they still depend on
aesthetics, are tending more and more toward precise, fully
documented investigations, for which monographs are the
proper framework. Literary criticism can only gain from such
studies, limited in their object, and rigorous in their form."[4]
Whether my essay satisfies the criteria imposed by these
observations, I am not in the best position to say, but I can at
least affirm the modesty of its aim. In fact, modesty, as a mask
perhaps for downright trepidation, is the only tone the literary
scholar can assume when he ventures into that disputed no-
man's land between literary history and art history.

Because my initial interest in the topic and my first
desultory reading occurred a decade ago while I was enjoying
the benefits of a Guggenheim Fellowship awarded for the in-
vestigation of another, unrelated topic, I wish to convey my
long overdue thanks to Gordon N. Ray and the Guggenheim
Foundation. I am grateful also to my friend and colleague,
Robert W. Dent, who read the manuscript with his usual
patient and discerning eye and helped me repair the seams and
iron out the wrinkles. I would like also to express my general

[4] Jean Seznec, "Art and Literature: A Plea for Humility," *New Literary History* 3 (1972): 574.

debt to James F. Beard's superb six-volume edition of Cooper's letters and journals, a work that reflects the highest standards of American literary scholarship.

1

Landscape and Prospect

Chuse then some *principal commanding theme*,
Be it lake, valley, winding stream, cascade,
Castle, or sea-port, and on *that* exhaust
Thy powers, and make to that all else conform.

WILLIAM GILPIN, "On Landscape Painting: A Poem"

I

In December of 1826, during a stay in Edinburgh, John James Audubon was informed that Sir Walter Scott wanted to meet him. Like so many of his contemporaries, Audubon had read Scott with sentiments verging on worship; for him, Scotland was, quite simply, "the land made famous by the entrancing works of Walter Scott." The prospect of meeting the romancer, as he contemplated it in his journal, filled the old woodsman with all the perturbations of a bride ("my head will droop, my heart will swell, my limbs will tremble, my lips will quiver, my tongue congeal"). During his wanderings in the American wilderness he had frequently invoked the spirit of the Great Unknown: "How many times I have longed for him to come to my beloved country, that he might describe, as no one else ever can, the stream, the swamp, the river, the mountain, for the sake of future ages." It troubled him that in a hundred years the primitive American landscape would have

disappeared: "Without Sir Walter Scott, these beauties must perish unknown to the world."[1] That Audubon himself was unequipped for this commemorative task is evident from his journals, where his feeling for landscape is minimal, his record of it casual.

He need not have been so pessimistic. *The Last of the Mohicans* had been published in February, two months before he sailed from New Orleans for Europe. Apparently Audubon had not read it, or if he had, the significance of the event had escaped him, for one would have had to have a very limited sensibility or a stubborn colonial feeling of inferiority not to see that the American forest had at last found its poet, and that whatever Cooper owed to the author of *Waverley*, the former was superior to Scott in the quality of his visual imagination and in his mastery of romantic setting. The impetus that Scott's example must have given Cooper, in a period whose whole tendency, as one art historian has defined it, was "the popularization of visual aesthetics,"[2] is undeniable. Scott's attempt, in both poetry and prose, to combine picturesque action with picturesque scenery is reflected in the American romancer's work from the outset. One of Cooper's motivations was to foster an appreciation of American scenery, as Scott almost singlehandedly had popularized the landscape of Scotland, and thus to strengthen the influence of local attachments as the surest ground of civic pride and responsibility.

But Scott from the beginning of his career had recognized severe limitations in his ability to master both the principles and practice of landscape art. His early years had awakened a passion for landscape, particularly when it included the ruins

[1] Maria R. Audubon, ed., *Audubon and His Journals* (New York: Dover Publications, 1960), I: 182–183.

[2] J. D. W. Murdoch, "Scott, Pictures, and Painters," *Modern Language Review*, 67 (1972): 42.

of castles and abbeys, "objects not only grand in themselves, but venerable from their association."[3] His father, responding to the boy's enthusiasm, had sent him to a drawing master, but as Scott recorded in his journal: "I could make no progress either in painting or drawing. Nature denied me correctness of eye and neatness of hand."[4] His frequent disclaimers in later years of connoisseurship ("I make no pretensions to judge of the fine arts" . . . "I am no judge of painting at all" . . . "My own acquaintance with art is so very small") could be taken as tokens of his characteristic modesty except that his contemporaries agreed with him. We have the testimony of the painter C. R. Leslie, who visited Abbotsford and with his host surveyed the local scenery: "He talked of scenery as he wrote of it—like a painter; and yet for pictures, as works of art, he had little or no taste, nor did he pretend to any. To him they were interesting merely as representing some particular scene, person, or event; and very moderate merit in their execution contented him."[5]

Leslie's last sentence merely confirms what any reader of Scott can infer for himself: that he has a sharper interest in the picturesque in human types and human events than in scenery. In the early (1808) autobiographical fragment that prefaces Lockhart's biography, Scott recounts his ineffectual attempts to learn to sketch, and adds: "But show me an old castle or a field of battle, and I was at home at once, filled it with its combatants in their proper costume, and overwhelmed my hearers by the enthusiasm of my description." Though his drawing master, whom he described as "a Smouch called Burrell," had no success in teaching him the

[3] J. G. Lockhart, *Memoirs of Sir Walter Scott* (London: Macmillan and Co., 1914), I: 30.

[4] W. E. K. Anderson, ed., *The Journal of Sir Walter Scott* (Oxford: Clarendon Press, 1972), p. 100.

[5] Quoted in Murdoch, "Scott, Pictures, and Painters," p. 39.

elements of painting or sketching, he was not, Scott admits, "useless to me altogether":

> He was a Prussian and I got from him many a long story of the battles of Frederick in whose armies his father had been a commissary or perhaps a spy. I remember his picturesque account of seeing a party of the *Black Hussars* bringing in some forage carts which they had taken from a body of the Cossacks whom he described as lying on the top of the carts of hay mortally wounded, and like the Dying gladiator eyeing their own blood as it ran down through the straw.[6]

With few exceptions, what seems to me to characterize the experience of reading Scott's romances is that after a lapse of time we can recall his characters and actions more vividly than his physical settings. (The reverse, I will be arguing, holds true for Cooper.)

When we try to explain why this is so, Scott himself leads us to the answer. If in poetry, he says, he has been to some degree successful in tracing the "principles" of scenery, "it has always been with reference to its general and leading features. . . . "[7] Again, this only confirms what the reader of Scott consciously or unconsciously has observed: that what he gives us are sketches rather than fully realized landscapes. Of his adolescent walking excursions Scott recalls that his principal motive was the pleasure of seeing romantic scenery and celebrated historical sites. "I do not by any means infer," he adds, "that I was dead to the feeling of picturesque scenery; on the contrary few delighted more in its general effect. But I was unable with the eye of a painter to dissect the various parts of the scene, to comprehend how the one bore on the other, to estimate the effect which various features of the view

[6] Anderson, *The Journal of Sir Walter Scott*, pp. 100–101.
[7] Lockhart, *Memoirs*, I: 40.

had in producing its leading and general effect."[8] Indicative, on the other hand, of the superior appeal for him of characters and events, he remarks of his early reading, "I gradually assembled much that was striking and picturesque in historical narrative." His son-in-law Lockhart, arguing from a theory of imitation no longer accepted, thought it all to the good that Scott failed as an artist: "He might have contracted the habit of copying from pictures rather than from nature itself; and we should thus have lost that which constitutes the very highest charm in his delineations of scenery, namely, that the effect is produced by the selection of a few striking features . . . neither too much nor too little."[9] On whichever side one may argue the merits of Scott's method, it must be conceded that he sought the general effect in his landscapes. Nor was this by any means an idiosyncratic trait. Steeped as he was in the tradition of English landscape painting, he could hardly have developed otherwise. "The English," Thomas Cole complained in a letter to William Dunlap, "have a mania for what *they* call generalizing," which, he added disparagingly, "is nothing more nor less than the art of making a little study go a long way."[10]

It is not my intention to overweight the argument in favor of a view that for all I know may be generally conceded, but it is my impression that the relative merits of Scott and Cooper as visual artists have not even been seriously considered. It is finally a question of what the two romancers made of their opportunities, which were about equal in spite of the fact that Cooper's aesthetic education began at a later point in his career

[8] Ibid., pp. 39–40.

[9] Ibid., p. 106.

[10] Louis L. Noble, *The Course of Empire, Voyage of Life, and Other Pictures of Thomas Cole, N.A., with Selections from Letters and Miscellaneous Writings; Illustrative of His Life, Character, and Genius* (New York: Cornish, Lamport, and Co., 1853), p. 114.

and under less favorable circumstances. Both grew up in the midst of what was loosely styled as "romantic" scenery, and both were strongly attracted to the arts, not simply as appreciators but as patrons and occasional collectors. And both were moved by the impulse to memorialize their native scenery. If Cooper is the superior visual artist, it is partly because of the greater challenge he had to meet and overcome, partly because of his greater ability to utilize what he learned from the arts of landscape painting and landscape gardening and from theories of the picturesque which, in spite of their waning vogue, his landscapes embody, though most consciously in his later fiction. The pages that follow will be mainly an attempt to explore this last proposition.

II

In *The Last of the Mohicans* Cooper was confronted for the first time with a problem inherent in all his frontier romances. Except for the episodes at Fort William Henry, all of the events take place against the vast and for the most part undifferentiated landscape of the primitive American wilderness—what Cooper and his contemporaries conventionally termed "the boundless forest" or "the interminable forest" and regarded as one of the natural accessories associated with "grandeur." In the absence of the artificial accessories so indispensable to the European romancer, how, Cooper must have asked himself, does the artist individualize such a setting? How will such a picture, regarded simply as a picture, compose? "It is impossible," William Gilpin had written three decades earlier, "to describe scenes, which, though strongly marked, have no peculiar features."[11] It was not simply that

[11] William Gilpin, *Observations on the Western Parts of England, Relative Chiefly to Picturesque Beauty, to which are added, A Few Remarks on the Picturesque Beauties of the Isle of Wight* (London: T. Cadell Jun. and W. Davies, 1798), p. 38.

the colonial settlements had no romantic associations, as certain native critics and novelists constantly emphasized, or even that they lacked, in Cooper's words, "that union of art and nature [that] alone can render scenery perfect."[12] These deficiencies, though formidable, were a matter of degree, as Brockden Brown earlier, Hawthorne later, and Cooper himself in certain of his romances, demonstrate. But as soon as an American romantic writer abandoned the settled areas of the Atlantic seaboard and carried his action into the forest, or for that matter onto the wide and featureless trans-Mississippi prairie, he created for himself a special problem, one that his predecessors, such as Scott or Mrs. Radcliffe, had not had to solve. "All nature here is new to art," wrote Cooper's younger contemporary, Thomas Cole, of his adopted country.[13] And if, as Cole insisted, this gave the American painter "privileges, superior to any other," it also created difficulties. The colonial poets had been drawn to the picturesque mode but were frustrated in their attempt to adapt its conventions to the description of native scenery.[14] They were defeated, as were so many writers of the next generation, novelists as well as poets, not simply by the absence in the American landscape of what James Callow terms "finish, associations, and ruins,"[15] but by the failure of their imaginations to cope with the new face of nature presented by the vast and unspoiled wilderness. Consequently it is not surprising that so much late eighteenth and early nineteenth-century natural description, in both

[12] James Fenimore Cooper, "American and European Scenery Compared," *The Home Book of the Picturesque* (New York: G. P. Putnam, 1851), p. 56.

[13] Noble, *The Course of Empire*, p. 202.

[14] For a discussion of this point see Eugene L. Huddleston, "Topographical Poetry in the Early National Period," *American Literature* 38 (1966–67): 303–322.

[15] James Callow, *Kindred Spirits: Knickerbocker Writers and American Artists, 1807–1855* (Chapel Hill: Univ. of North Carolina Press, 1967), p. 127.

poetry and prose, should derive from the Ossianic tradition, with its emphasis on the sublime, as a way of asserting the qualities of untrammeled nature, rather than from the picturesque tradition, which in its European expression depended on a milder nature, an "improved" and cultivated nature, and for this reason resisted adaptation.

In a long and, as was the fashion in 1826, rather patronizing essay on the first two Leatherstocking tales for the *North American Review*, W. H. Gardiner made some observations on Cooper's description of natural scenery that could hardly have been more misleading. After explaining that Cooper "chooses to paint upon the grand scale" and pursues only the grand effects, he concludes:

> He aims at something striking and overwhelming; and in the attempt often becomes confused. We find ourselves in the midst of huge rocks, and over-hanging woods, and tumbling cataracts, with a great mist, and a great noise, *and we are utterly unable to settle the relative position of these objects, so as to form any distinct picture from them in the mind.*[16] (emphasis mine)

Gardiner is referring to *The Last of the Mohicans* and apparently to the episode at Glenn's Falls. When on the well-known occasion of Cooper's visit to Glenn's Falls in 1825 with a party of English visitors the fourteenth Earl of Derby had suggested that the cavern and the falls were "the very scene for a romance," Cooper had promised to incorporate the scene into his next work.[17] He did so in *The Last of the Mohicans*, and with a skill that makes nonsense of Gardiner's strictures. The exciting events at the falls occupy five chapters of the

[16] W. H. Gardiner, "Cooper's Novels," *North American Review* 23 (1826): 156.

[17] Susan Fenimore Cooper, Introduction to *The Last of the Mohicans* (New York and Cambridge: Houghton Mifflin and Co., 1876), pp. ix–xi.

narrative; for this reason, if for no other, the reader must be able to visualize the scene in such a way that he can orient himself at any moment during the headlong course of the action. The focus of the composition is strikingly definite: an island in the center of the narrow river gorge, situated below the falls and above the cataract. On the island are two caverns which offer Hawkeye's party a means of concealment from Magua and his band. But because it is night when the fugitives take possession, Cooper has Hawkeye, who is familiar with the surroundings, volunteer "an untutored description" of their refuge. What follows is a coup d'oeil, taken in daylight from an imagined vantage point at the summit of the falls and exhibiting, incidentally, more sensitivity to aesthetic considerations than Hawkeye's modesty admits or his creator's sense of decorum ought to allow ("the whole design of the river seems disconcerted," remarks the guide, as if he were a landscape gardener discussing "capabilities" or a painter appraising a detail of the scene before him). By means of such devices—and the prospect view is one of Cooper's most dependable—the stage is marked out for the action that follows.

It is inconvenient at this point to do more than glance at the variety of picturesque sites that Cooper exploits for the subsequent episodes of his narrative—and that in any case, have been eclipsed in most readers' minds by the splendor of Glenn's Falls. But I would point out that in each instance, as well as in the romances that followed *The Last of the Mohicans*, Cooper has sought out some natural or artificial accessory in the landscape that will be strikingly visible and that will serve as a central magnet, so to speak, around which one phase of the action may cohere. The events of the narrative immediately succeeding those at Glenn's Falls occur

on one of those steep, pyramidal hills which bear a strong
resemblance to artificial mounds, and which so frequently
occur in the valleys of America. The one in question was
high and precipitous; its top flattened, as usual; but with
one of its sides more than ordinarily irregular.

On the flat summit of this natural stronghold Hawkeye and
Chingachgook surprise Magua's forces. The action that
follows is framed by the circumference of the tableland; we
can follow the combat between Chingachgook and Magua as
it "[moves] from the center of the little plain toward its bound-
ary," or as Magua rolls over the edge of the precipice and es-
capes into the thicket at its base. Following the rescue the
reunited party proceeds toward Fort William Henry. They
pause at "a solitary and silent spring" (later, Cooper tells us in
a footnote, to become a famous spa); that night they camp in
"an open space, that surrounded a low green hillock . . .
crowned by [a] decayed blockhouse." Nearby are the graves
of dead Mohawks commemorating an ancient encounter with
the Mohicans, in which Hawkeye—"then a younker," as he
recalls—had taken part. The ruin, the graves, even the mention
of the future spa, lend themselves to a strategy that will be
more apparent in a later context of this essay—that is,
Cooper's effort to adapt the historical romance to native con-
ditions and to impart romantic associations to the local setting:

> Such memorials of the passage and struggles of man are yet
> frequent throughout the broad barrier of wilderness which
> once separated the hostile provinces, and form a species of
> ruin that are intimately associated with the recollections of
> colonial history, and which are in appropriate keeping with
> the gloomy character of the surrounding scenery.

The events of the next six chapters (XIV through XIX) oc-
cur in and around Fort William Henry, but once this violent
episode is concluded and Cooper, resuming the controlling

flight-capture-pursuit-rescue pattern of his narrative, has plunged his characters back into the interminable forest, we find him reconnoitering again for the unusual (or, in the parlance of the day, the "peculiar") and visually memorable locale. Now it is a beaver village on the margin of a lake (Chapter XX) where the pursuers are reunited with David Gamut and where later Chingachgook disguises himself as a beaver and hides in one of the lodges; now the village of the Delawares perched on the "platform of rock," the "natural rocky terrace" that Thomas Cole, in both versions of his *Cora at the Feet of Tamenund*, chose as the commanding center of his landscape; and, finally, the ledge of rock, a thousand feet above the valley floor, where Cora, Uncas, and Magua meet their violent deaths in the theatrically spectacular denouement.

Except for the passage in Chapter XVIII that contrasts the desolate aftermath of the massacre with the earlier scenes of Fort William Henry under siege, it is the pictorial, rather than the moral or symbolic values of setting that Cooper has emphasized. He has taken advantage of every natural accessory—waterfall, watercourse, open glade, spring, pyramidal mound, beaver pond, table rock, and precipice—as well as the meager artificial accessories testifying to a frontier civilization and a frontier past, that will enable him to compose what Balzac (writing of *The Pathfinder*) termed "a succession of marvelous tableaux."[18] Cooper's imagination was solicited by a bold or unusual feature of actual topography as surely as Hawthorne's was by a potential symbol or James's by the stray figure *en disponibilité*. Susan Cooper tells us that after his western trip in 1847, when he had revisited Niagara Falls, "the idea of an Indian narrative, connected with Niagara, occurred to him; he would have dated it a century earlier, and have carried a party of savages

[18] Katherine Prescott Wormeley, tranl., *The Personal Opinions of Honoré de Balzac* (Boston: Little Brown, 1899), p. 116.

to Goat Island ere any bridge had been built, and while the adjoining country was still a forest."[19]

That the setting in many of his romances may enhance symbolically the moral or dramatic elements is also apparent, and Donald Ringe has examined several of Cooper's works from this point of view. The house of Colonel Wharton in *The Spy*, for example, is located midway between the opposing forces, and this neutral ground, as Ringe indicates, "defines the problem that the characters face in resolving their conflicting interest," for as "a physical and moral no-man's land, it reflects the ambiguities that pervade the entire novel."[20] But Cooper by no means makes his setting perform this function consistently. In the European romances, yes, and particularly in *The Heidenmauer* and *The Headsman*; in the sea romances to a lesser degree. But in the romances of the forest only intermittently (as for example in *The Prairie*) and with a certain perfunctoriness, presumably because of the thinness of the historical record and consequently of civilized forms, aspects, manners, and institutions, with all that circumstance implies for the task of eliciting the deeper social and moral drama.

More consistently, what Cooper perceives is the value of the physical setting both for its appeal to the reader's imagination and as a control over its autonomy. The Four Corners of *The Spy*, the "Newport Ruin" in *The Red Rover*, or the ruined building in *The Pilot*, from which the action radiates as spokes from a hub, are more useful finally as points of reference than as elements helping to define the theme. There is, in fact, a more apparent common denominator in Cooper's uses of setting if we confine ourselves to aesthetic or practical as opposed to metaphysical considerations. His career begins

[19] Susan Fenimore Cooper, *Pages and Pictures, from the Writings of James Fenimore Cooper, with Notes by Susan Fenimore Cooper* (New York: W. A. Townsend and Co., 1861), p. 379.

[20] Donald Ringe, *James Fenimore Cooper* (New York: Twayne Publishers, Inc., 1962), p. 28.

at the height of the development, in this country at least, of the picturesque phase of art initiated in England almost a century earlier with the realization, in Samuel Monk's words, that it was "possible for scenery to be valued generally for its composition and not primarily for its ability to awaken emotions."[21] Refining on this suggestion, Martin Price proposes as one aspect of picturesque theory in its subsequent development "the dissociation of visual, pictorial, or generally aesthetic elements from other values in contemplating a scene."[22] By Cooper's time this was a settled habit—a mode of vision from which no one as familiar with the arts as Cooper would have been immune—though by mid-nineteenth century, when the romancer's career was about to end, the picturesque fervor had diminished and picturesque theory had become a tired convention.

In the deliberately limited view I am taking, *The Last of the Mohicans* is a transitional work. It is the last of the five romances Cooper published before he embarked with his family for the seven-year sojourn in Europe. The works that follow it exhibit, as we shall see, an even more conscious and skillful use of setting. Cooper begins to see more clearly with the landscape painter's eye; he is more aware of such pictorial values as unity, variety, and contrast. That his European experience was responsible for this development is clear even though he left so meager a record, in his letters and journals, of his aesthetic education that we must infer what we can mainly from his travel books and from the romances themselves.[23] Prior to *The Last of the Mohicans*, Cooper had

[21] Samuel Monk, *The Sublime: A Study of Critical Theories in XVIII-Century England*, (Ann Arbor: Univ. of Michigan Press, 1960), p. 209.

[22] Martin Price, "The Picturesque Moment," *From Sensibility to Romanticism: Essays Presented to Frederick A. Pottle*, ed. Frederick W. Hilles and Harold Bloom (New York: Oxford Univ. Press, 1965), p. 260.

[23] Professor James Beard has written me that it probably is impossible at this late date to reconstruct the contents of Cooper's personal library, because, as he remarks, "books seem to have run through the household

been, like the earliest American landscape painters, mainly a topographical artist who, in his descriptions of the Hudson River Highlands in *The Spy*, the port of Boston in *Lionel Lincoln*, and Templeton in *The Pioneers*, was delineating actual scenes, and with a livelier sense of the value, for narrative purposes, of the prospect view as opposed to the landscape viewed from a lower altitude. In *The Last of the Mohicans* —that is, with his first imaginative foray into the wilderness—he began to cultivate the art of landscape with a resourcefulness not evident in his earlier romances.

The last two frontier romances Cooper wrote before his fiction shifted to European settings and to a more intensive concern with social and political issues were *The Prairie* (1827) and *The Wept of Wish-ton-Wish* (1829), the former finished in Europe, the latter written wholly in his new surroundings. Both exhibit the economy of locale that, except in an occasional work like *The Last of the Mohicans*, one thinks of as characteristic of his method. In *The Prairie* Cooper risked one of his boldest and most theatrical strokes. As landscape, "the wild and naked prairies" of the trans-Mississippi West, however sublime in their effect on the observer, offered nothing but a "monotony of view," a conjunction of earth and sky, a flat expanse where the winds "rioted in wantonness across wastes where neither tree, nor work of man, nor mountain, nor obstacle of any sort, opposed itself to their gambols." Where, in short, there would be for the landscape painter no commanding feature, no natural or artificial accessory to intercept the eye, and, for the fictional landscapist, no landmark which he could utilize as a base of operations, so to speak, and with reference to which he could order spatially his sequence

in a stream and then disappeared," becoming a permanent or temporary part of other collections and in general undergoing a process of redistribution lasting over a century.

of pursuits, escapes, Sioux raids, buffalo stampedes, and prairie fires. Cooper is willing, however, to play fast and loose with geological probability: "Amid the monotonous rolling of the prairie, a single naked and ragged rock arose on the margin of a little watercourse." This standing rock, which dominates the scene through at least half the action of *The Prairie*, is an example of what Cooper, in *Wyandotté*, called "those capricious formations that are often met with on the surface of the earth"—the *lusus naturae* that William Gilpin, seeking beauty "in her *most usual* forms," excluded from the picturesque because it was "the naturalist's province, not the painter's,"[24]—but which Cooper found indispensable to his art. It is on the nearly inaccessible summit of this standing rock that Ishmael Bush and his family have raised their breastwork of logs and stones and pitched their makeshift dwelling. By day the citadel is visible from any vantage point within the circumference of the action; at night, thanks to "the bright, flashing fire . . . burning on the centre of its summit," it becomes a beacon, "some tall Pharos placed in the centre of the deserts, to light such adventurers as wandered through their broad wastes." As Cooper constantly reminds us, the prairie is like the ocean, a sublime "waste of waters" stretching to the horizon. "In this wilderness of grass and reeds," warns his aged trapper, "you are like a vessel in the broad lakes without a compass." In the absence of a compass Ishmael's citadel provides a gauge of distance and direction. On a sortie from the rock, the Bush party proceeds "until their distant fortress had sunk so low, as to present an object no larger nor more distinct than a hazy point, on the margin of the prairie." When the trapper's party is trying to evade detection by the Bush family, Cooper, always scrupulous in

[24] William Gilpin, *Three Essays on Picturesque Beauty, Picturesque Travel; and on Sketching Landscape, to which is added a poem, On Landscape Painting* (London: R. Blamire, 1792), p. 43.

managing his spatial coordinates, is able to plot their route
with reference to the rock:

> The old man now profited by the formation of the land to
> take another direction with a view to elude pursuit, as a
> vessel changes her course in fog and darkness to escape
> from the vigilance of her enemies.

> Two hours passed in the utmost diligence enabled them
> to make a half circuit around the rock, and to reach a point
> that was exactly opposite to the original direction of their
> flight.

It should be noted in passing that Ishmael Bush's citadel not
only provides a commanding center for the landscape and a
central magnet for the action; it has another function, one that
will be assumed in the later forest romances by Muskrat Cas-
tle in *The Deerslayer*, the blockhouse on one of the Thousand
Islands in *The Pathfinder*, Ravensnest in the Littlepage trilogy,
the Hutted Knoll in *Wyandotté*, and the abandoned *chienté* in
The Oak Openings. These structures are the native equivalent
of those innumerable abbeys, castles, and ruined strongholds
in Cooper's European romances, and they possess, in the later
fiction, some of the associative value of their counterparts.

More immediately, the stronghold reappears in *The Wept
of Wish-ton-Wish*, again in the center of the picture, again
marked by certain unique features, and, surrounded as it is by
the interminable forest, again providing Cooper with a vividly
defined amphitheater for his action. In the second chapter
Captain Mark Heathcote, the "stern, fanatical soldier" who
has removed his family into the wilderness bordering the
Connecticut River, views his settlement from a "small
eminence," taking in a prospect that comprises the setting of
most of the subsequent action:

> A small tributary of the Connecticut divided the view into
> two nearly equal parts. The fertile flats that extended on
> each of its banks for more than a mile had been early

stripped of their burden of forest, and they now lay in placid meadows, or in fields from which the grain of the season had lately disappeared, and over which the plough had already left the marks of recent tillage. The whole of the plain, which ascended gently from the rivulet towards the forest, was subdivided into enclosures by numberless fences, constructed in the rude but substantial manner of the country.

From this wide-angle view of the clearing Cooper gradually constricts the focus from the perimeter to the center of his composition—to the "natural elevation in the land, which rose so suddenly on the very bank of the stream as to give it the appearance of a work of art." It is on the summit of this "flattened cone" that Captain Heathcote has raised his fortification, a hollow quadrangle composed of various domestic structures built along the "verge of the natural declivity" and with the citadel, or blockhouse, at the center of the enclosure: "But the building which was most conspicuous by its position, *no less than by the singularity of its construction*, stood on a low, artificial mound, in the centre of the quadrangle. It was high, hexagonal in shape, and crowned with a roof that came to a point, and from whose peak rose a towering flagstaff" (emphasis mine). From this temporary resting-point the eye of the observer is drawn back by degrees to the perimeter of the view, past the "unbroken line of palisadoes" about halfway up the mound, past the cluster of barns, stables, and sheds "at no great distance from the base," to the margin of the forest—the ultimate context of so many of Cooper's romances: "With the solitary exception of the mountain-side, and of here and there a wind-row . . . the eye could find no other object to study in the vast setting of this quiet rural picture, but the seemingly endless maze of the wilderness."

This elaborate topographical survey, occupying most of Chapter II, is required, obviously, because most of the action

will take place in this clearing on the banks of the Connecticut
and the reader will have to have both the general view and its
component features in mind if he is to follow the intricate
pattern of movement and countermovement characteristic of
Cooper's actions. More particularly, it will be a necessary
prelude, this "quiet rural picture," to the effect Cooper wants
to secure in Chapter XVI when, following the Indian attack,
the burning of the stockade, and the supposed death of the oc-
cupants of the blockhouse, he will reproduce the picture, as he
had done for a similar purpose in *The Last of the Mohicans*, in
a more somber tone ("With morning . . . a landscape very
different from that placed before the mind of the reader
presented itself in the valley of the Wish-ton-Wish"). It is now
spring and the buds are swelling. "But the principal and most
melancholy change was in the more artificial parts of the view.
Instead of those simple and happy habitations which had
crowned the little eminence, there remained only a mass of
blackened and charred ruins." There follows an inventory of
the scene, desolate after the holocaust, and then the
miraculous appearance, from the deep well below the ruined
blockhouse, of the survivors—a symbolic rebirth, as Donald
Ringe has noted, an April resurrection of the settlement.[25]
Enough certainly has been said elsewhere of Cooper's
characteristic device of presenting the same landscape in con-
trasted moods for the purposes of moral or philosophical com-
mentary, and of the similarity of this technique to that of
Thomas Cole's allegorical landscapes. My emphasis, conse-
quently, in this instance as in earlier ones, is on Cooper's
visual strategies.

III

Before examining the years Cooper spent in Europe and the
record he left in his travel books of his profound appreciation

[25] Ringe, *James Fenimore Cooper*, p. 52.

of European landscape, we might ask what kinds of pictures Cooper in these early years thought he was painting—more specifically, whether his perception of landscape was consciously influenced by current aesthetic categories. Aside from the question of whether the pictures are of real landscapes (*The Pioneers* and much of *The Last of the Mohicans*), with whatever modifications, or of imagined landscapes (*The Prairie* and *The Wept of Wish-ton-Wish*), Cooper generally characterizes them—when, indeed, he bothers to characterize them at all—as "romantic," a term that seems to apply equally to the wild scenery of Glenn's Falls and the pastoral scenery of Lake Otsego. We can assume that at this period his landscapes are "romantic" less by reason of their historical associations than by reason of other landscape conventions derived from prose romance. At this stage Cooper makes no distinction between the terms "romantic" and "picturesque"; in fact, he seldom employs either term, though when he does they are interchangeable.[26] In the first edition of *The Pioneers* he twice refers to the "romantic character" of the scenery around Templeton. When he revised the text for the Bentley Standard Novels edition (1832) he altered the first instance to "that romantic *and picturesque* character" (emphasis mine). The addition is significant, for reasons that will be clear later, but it does not help us to answer the question at the beginning of this paragraph. A similar uncertainty of terminology is evident in *Notions of the Americans*, written abroad and first published in London in June, 1828, but completed prior to that long period of travel and residence on the continent which furthered so decisively his aesthetic education. Here, in fact, the usual connotations of "romantic" and "picturesque"

[26] As opposed to his practice in *Wyandotté*, for example, in which the term "picturesque" appears about a dozen times in the early chapters and the term "romantic" not at all.

seem to be reversed. Employing a vocabulary usually iden-
tified with the picturesque, Cooper describes the Hudson
Highlands as "a succession of confused and beautifully
romantic mountains, with broken and irregular summits." It is
in fact a Gothic landscape:

> Rocks, broken, ragged, and fantastic; forests, through
> which disjointed precipices are seen forming dusky
> backgrounds; promontories; dark, deep bays; low sylvan
> points; elevated plains; gloomy, retiring vallies; pinnacles;
> cones; ramparts that overhang and frown upon the water;
> and, in short, almost every variety of form in which the
> imagination can conjure pictures of romantic beauty, are
> assembled here.[27]

The effect is deliberately impressionistic; what we have in-
stead of a picture is a catalogue of picturesque motifs casually
subsumed under the rubric of "romantic beauty." And, as if
to underline his uncertainty about aesthetic categories, Cooper
a moment later is describing the tranquil scenery between
Hudson and Albany as "picturesque and exceedingly agree-
able." Accepting for the occasion the categories long in vogue
in England, we would expect the adjective "agreeable" to be
applied more appropriately to the "beautiful" and the adjec-
tives "broken," "irregular," "ragged" to the "picturesque."
But Cooper, no less than his contemporary, Walter Scott, ap-
parently is taking his cue from the tradition best defined by
Richard Payne Knight in his *Inquiry* (1805):

> There is another species of scenery, in which every object is
> wild, abrupt, and fantastic;—in which endless intricacies
> discover, at every turn, something new and unexpected; so
> that we are at once amused and surprised, and curiosity is

[27] James Fenimore Cooper, *Notions of the Americans: Picked up by a
Travelling Bachelor* (London: Henry Colburn, 1828), I: 273–274.

constantly gratified, but never satiated. This sort of scenery we call *romantic;* not only because it is similar to that usually described in romances, but because it affords the same kind of pleasure, as we feel from the incidents usually related in such of them as are composed with sufficient skill to afford any pleasure at all.[28]

Such a definition of "romantic," with its Radcliffean suggestions and its emphasis on novelty and intricacy as characterizing both the setting and the action of romances, indicates the probable affinity of these elements in Cooper's mind. He would regard as equally "romantic" both the events of *The Last of the Mohicans* and the memorable locales in which they occur. The term "picturesque," on the other hand, would at this stage imply for him no particular mode of vision, no principles by which the term might be assigned a realm of its own, and no function in comprehending and ordering the elements of a landscape. In short, he would take the term as meaning no more than is conveyed in its original sense of "capable of being represented in a picture." But when following his return from Europe he next views the Hudson Highlands, on this occasion through the trained perceptions of the Effingham party in *Home as Found,* we will be presented with a landscape very different from those in *The Spy* and *Notions of the Americans.* The nature of that difference will be appreciable, however, only after we have traced in Chapters III and IV the development abroad of that connoisseurship for which the Effinghams are Cooper's fictional surrogates.

With the question still in mind as to what kinds of pictures Cooper was consciously delineating in this early period, we may turn again to *Notions of the Americans* and to another

[28] Richard Payne Knight, *An Analytical Inquiry into the Principles of Taste.* 4th ed. (London: T. Payne, 1808), p. 195.

type of landscape, the possibilities of which are latent in the pastoral settings of *The Pioneers* and in the early chapters of *The Wept of Wish-ton-Wish* but are realized fully only in such later works as *Wyandotté* and *The Crater*. It is the symbolic "middle landscape," located somewhere between nature and civilization, that Leo Marx has defined so brilliantly in *The Machine in the Garden*, tracing its emergence through such precursors of Cooper as Robert Beverley, Jefferson, and Crèvecoeur, and such contemporaries as Thoreau, Emerson, and Hawthorne, but failing to consider, for reasons that are not clear, Cooper's role in the development. In *Notions of the Americans* Cooper's imagined foreign visitor, the Count de——, is writing to a friend in England for whose benefit he designs an ideal prospect, composed of representative motifs drawn from New England scenery:

> Fancy yourself on some elevation that will command the view of a horizon that embraces a dozen miles. The country within this boundary must be undulating, rising in bold swells, or occasionally exhibiting a broken, if not a ragged surface. But these inequalities must be counterbalanced by broad and rich swales of land, that frequently spread out into lovely little vallies. If there be a continued range of precipitous heights in view, let it be clad in the verdure of the forest. If not, wood must be scattered in profusion over the landscape, in leafy shadows that cover surfaces of twenty and thirty acres. Buildings, many white, relieved by Venetian blinds in green, some of the dun colour of the time, and others of dusky red, must be seen standing amid orchards, and marking, by their positions, the courses of the numberless highways. Here and there, a spire, or often two, may be seen pointing toward the skies from the centre of a cluster of roofs. Perhaps a line of blue mountains is to be traced in the distance, or the course of a river to be followed by a long succession of fertile meadows. The whole country is to be subdivided by low stone walls, or

wooden fences, made in various fashions. . . . Cattle are to be seen grazing in the fields, or ruminating beneath the branches of single trees, that are left for shade in every pasture, and flocks are to be seen clipping the closer herbage of the hill sides. In the midst of this picture must man be placed, quiet, orderly, and industrious. By limiting this rural scene to greater, or less extensive, scenes of similar quiet and abundance, or occasionally swelling it out, until a succession of villages, a wider range of hills, and some broad valley, through which a third rate American river winds its way to the ocean, are included, your imagination can embrace almost every variety of landscape I beheld in the course of my journey.[29]

The scene embodies the Jeffersonian idyll that Henry Nash Smith has evoked in *Virgin Land:* the American landscape as a prosperous, peaceful garden, exemplifying that "middle condition" of life celebrated in Crèvecoeur's letters, with the symbolic figure of the yeoman, "quiet, orderly, and industrious," in the center of the picture. Cooper does nothing to extend the implications of his tableau beyond the suggestions of rural tranquillity and that variety and abundance which in the tradition of seventeenth-century landscape art would have testified to God's beneficence and thereby made its contribution to that complex of ideas called Christian Optimism. But in a later, similar prospect (*Notions,* I, 331–34), taken from a height some fifty miles west of Albany, and therefore presumably a topographical rather than an ideal landscape, Cooper introduces a new element. At the conclusion of the survey, the narrator suggests to his American companion, John Cadwallader, that the scene "only [wants] the recollections and monuments of antiquity to give it the deepest interest."[30] The latter's response echoes the conventional American defense: "The moral feeling with which a man of sentiment

[29] Cooper, *Notions of the Americans,* I: 81–82.
[30] Ibid., p. 334.

and knowledge looks upon the plains of your hemisphere, is connected with his recollections; here it should be mingled with his hopes." European landscape evokes the past; the American, surveying his native scenery, is led to contemplate the present and the future. Beginning in Jefferson's time, as Leo Marx has demonstrated, the rural landscape is "the cardinal image of American aspirations."[31] What Cooper's two prospect views in *Notions of the Americans* exploit—the first implicitly, the second explicitly—is (again in Marx's terms) "the function of landscape as a master image embodying American hopes."[32] To the spectator, Cadwallader argues, they promise "all that reason allows may be hoped for in behalf of man"; the American therefore lives "in the excitement of a rapid and constantly progressive condition." It is only in passing, and in very general terms, that Cadwallader responds to the main thrust of his guest's complaint with the observation that "it is vain to say it is a land without recollections." The progress of civilization in the valley at their feet has extended over a century, and its achievements are representative of the settled area "for a thousand miles west." This rebuttal permits Cadwallader to summarize his counterargument by uniting past, present, and future in one of those prophetic visions that fill the literature of the young republic:

> I have stood upon this identical hill, and seen nine tenths of its smiling prospect darkened by the shadows of the forest. You observe what it is today. He who comes a century hence, may hear the din of a city rising from that very plain, or find his faculties confused by the number and complexity of its works of art.

This is the mood in which Cooper at this very period would

[31] Leo Marx, *The Machine in the Garden: Technology and the Pastoral Ideal in America* (New York: Oxford Univ. Press, 1964), p. 141.
[32] Ibid., p. 159.

have surveyed the valley of the Susquehanna and the progress of civilization in the neighborhood of Cooperstown; it is the mood, in fact, of that opening description in *The Pioneers* which defines the pastoral setting and concludes with a tribute to the progress of New York State, whose citizens "are maintained in abundance, and can look forward to ages before the evil day must arrive, when their possessions shall become unequal to their wants"; but it is not a mood that will survive Cooper's return from Europe and his discovery that the "evil day" is in fact at hand and that, as the Littlepage trilogy will testify, greed already has outstripped possession. When he wrote *Notions of the Americans* he had already published *The Pioneers* and was about to write *The Wept of Wish-ton-Wish*, both of which prove that he was not unmindful of those threats to the future of the middle landscape—those encroachments of nature or civilization that, through sudden violence or long attrition, defeated the most hopeful social and political experiments. But his sense of the downward course of human events and the defeat of human aspirations is more active in his fiction than in an *apologia pro patria sua* like *Notions of the Americans*. Both *The Pioneers* and *The Wept of Wish-ton-Wish* introduce us to a tranquil setting and an idyllic way of life only to chronicle their entire or partial destruction, whether, as in the former, through the waste of natural resources or, as in the latter, first through Indian attack (the encroachment of nature) and later, after Heathcote's settlement has been reestablished, through the agency of spiritual pride and fanaticism (the encroachment of civilization). But at the outset of both novels—as later in *Wyandotté* and *The Crater*—Cooper gives us his version of that rural haven whose archetype Leo Marx has found in Virgil's first eclogue and whose most suggestive nineteenth-century American embodiment he finds in Hawthorne's

Sleepy Hollow ("the good place," Marx comments, "is a love-ly green hollow").[33]

If Cooper's two prospect views in *Notions* may be dis-tinguished according to their symbolic intentions, the second representing a fuller, or at least more explicit attempt to invest the landscape with meaning, we may discern in this period a third and final development in his use of the landscape of symbol. In his introduction to *The Heidenmauer* (1832) Cooper, drawing on the actual topography and "artificial accessories" of the environs of Durkheim, composes another kind of prospect view, an allegorical landscape—rather cluttered, to be sure—that provides both a historical summary of "the progress of civilization, of the infirmities and constitu-tion, of the growth and ambition of the human mind" and the setting, complete with specific locales, for the action of the romance that follows. The observer is positioned on the sum-mit of Teufelstein, the Devil's Rock, which recalls for him "the age of furious superstition and debased ignorance." In keeping with the historical chronology, his attention is first directed to the Roman Camp, a relic of the first age of paganism, on the slope of the mountain facing the Teufelstein. His imagination then summons a picture from the next phase of history, of the invading barbarians, the Huns, pouring into the Camp and subduing it. Next, his attention is drawn to the baronial Castle, "with its feudal violence and its progeny of wrongs," and, finally, to the Abbey, and the stage is set for that conflict between temporal ambition and Christian charity that will furnish Cooper with his theme for the romance. If nothing else, it is clear from this experiment in allegorical landscape—an experiment more congenial, one would think, to the later work of Thomas Cole—that Cooper is attempting to capitalize on what Europe could give him and his native

[33] Ibid., p. 22.

land could not: the deeper moral significance that the Euro-
pean landscape, with its monuments of the past, seemed
capable of expressing. Of his trip up the Rhine he recalled in
his introduction to the romance: "There were ruined castles,
by scores; gray fortresses; abbeys, some deserted, and others
yet tenanted; the seven mountains, cliffs and vineyards. At
every step we felt how intimate is the association between the
poetry of nature and that of art; between the hillside with its
falling turret, and the moral feeling that lends them interest."
No matter that he went on to argue the scenic superiority of
the Hudson over the Rhine; the fact remains, he must con-
cede, in a spirit less partisan than John Cadwallader's, that
"time is wanting to mellow the view of our own historical
sites; for the sympathy that can be accumulated only by the
general consent of mankind, has not yet clothed them with the
indefinable colours of distance and convention."

IV

"The love of prospect," wrote Humphry Repton, "seems a
natural propensity, an inherent passion of the mind."[34] In the
arts, however, it is a propensity which only the poet and the
novelist can indulge. The landscape painter, like the amateur
photographer, does so at his peril. Writers on the picturesque
were unanimous in condemning the prospect view on canvas
because of its extent and its lack of variety, detail, and
foreground interest. William Gilpin argued the "absurdity of
carrying a painter to the top of a high hill, to take a view"
because "extension alone, though amusing in nature, will
never make a picture."[35] Uvedale Price, in his *Essays on the*

[34] Humphry Repton, Letter to Uvedale Price, July 1, 1794, reproduced
in Price's *Essays on the Picturesque, as Compared with the Sublime and
the Beautiful; and, on the Use of Studying Pictures, for the Purpose of
Improving Real Landscape* (London: J. Mawman, 1810), III: 19.
[35] William Gilpin, *Observations on the River Wye, and Several Parts*

Picturesque, stressed the lack of foreground objects:

> A prospect of mere extent, if that extent be very great, has,
> without any striking features, a powerful effect on the
> mind. If to extent you add a richly wooded and cultivated
> country, with a varied boundary of hills or mountains; and
> to that again, effects of water and buildings, it is enchant-
> ment. If from a high summit you look from mountain to
> mountain, across their craggy breaks, and down into their
> recesses, it is awful and sublime. Yet neither such grand nor
> such beautiful prospects as those I have just described, nor
> yet many others of intermediate styles and degrees, are in
> general proper subjects for pictures. This I imagine to arise,
> not from the height whence they are viewed, but from
> another cause which equally operates on all views; namely,
> the want of any objects of importance in the fore-ground,
> or the middle distance.[36]

Insisting, like Gilpin before him, that the distinction between a
landscape and a prospect is the distinction "between what is,
and what is not proper for a picture in point of composition,"
Price concluded that "any view that is unbroken, unvaried,
undivided by any objects in the nearer parts, whether it be
from a mountain or from a plain, is, generally speaking, ill
suited to the painter." Thomas Cole, climbing Chocorua Peak
in October, 1828, noted in his sketchbook that although "on
every side prospects mighty and sublime opened upon the
vision," with mountains, streams, woodlands, dwellings, and
cultivated farmlands weaving themselves "into a vast and
varied landscape," the scene, for all its beauties, was "one too
extended and map-like for the canvas."[37]

*of South Wales, etc., Relative Chiefly to Picturesque Beauty; Made in the
Summer of the Year 1770,* 3d ed. (London: R. Blamire, 1792), p. 128.

[36] Uvedale Price, *Essays on the Picturesque,* III: 128.

[37] Noble, *The Course of Empire,* p. 96.

Cooper, when he wrote his *Sketches of Switzerland*, was merely rehearsing what was by then a commonplace:

Most views lose in the detail what they gain by extent, by climbing mountains. After the first feeling of satisfaction at commanding so many objects with the eye is abated, the more critical amateur misses those minuter points of beauty which we come most to love, and which are lost for the want of the profile in bird's eye prospects.[38]

The corollary of his observation is that landscape should be viewed, whether by the "critical amateur" or the painter, from a lower vantage point. "Looking down from lofty heights astonishes, and, for a time, excites the feelings," Cooper wrote in another context, "but I cling to the opinion, that we most love the views, at which we are accustomed to gaze from the margin of quiet waters, or from the depths of valleys."[39]

Aesthetic rules and tender sentiments notwithstanding, the author of the *Gleanings in Europe* volumes conscientiously described such views as that of Paris from the heights of Montmartre, Florence from Bellosguardo, the harbor of Genoa and the bay of Naples from the hills behind these cities. From the beginning of his career as a writer of fiction, Cooper employed the prospect view as one of his most dependable narrative tactics. *The Spy* has two prospect views, the first in Chapter XXV when Frances and the housekeeper, Katy, climb to a summit of the Hudson Highlands, and the second in Chapter XXXII when Harvey Birch and Captain Wharton pause in their flight on another height above the Hudson. At this earliest stage of his career, Cooper's treatment of the scene is generalized and somewhat imprecise, and his descriptions are punctuated by Baedeker-like comments ("To be seen in

[38] James Fenimore Cooper, *Sketches of Switzerland* (Philadelphia: Carey, Lea, and Blanchard, 1836), I: 189.

[39] Cooper, *Sketches of Switzerland*, II: 42.

their perfection, the Highlands must be passed immediately
after the fall of the leaf"). By the time he writes *The Last of the
Mohicans* the prospect has become an integral feature of his
method, because, as we have noted, it establishes both the
larger spatial context in which his action takes place and the
relative disposition of objects within view in order that the
reader's vision of the events may be enhanced as well as con-
trolled. In a late work such as *The Pathfinder* the device is so
indispensable that at regular intervals, corresponding with the
major shifts in setting, Cooper will send his heroine, Mabel
Dunham, scrambling up the nearest hill or to the summit of a
blockhouse in order to get her bearings and, in the process, to
accommodate the reader by marking out the scene for the next
phase of the action.

The problem for the prose landscapist, as writers on the
picturesque defined it, was essentially that of the painter: in
ideal landscapes to imagine the composition as a whole and
then adapt the parts; in topographical landscapes to accept the
parts as given and form them into a whole. But the former en-
joys a greater freedom in being able to enlist the reader's imag-
ination in evoking the scene. The poet, Gilpin observed—
and he could as well be speaking of the prose writer—has an
advantage over the painter; he need only "*excite* ideas,"
whereas the painter must "*represent* them."[40] It would be
difficult for the painter to represent the kind of ideal prospect
that Cooper, in *Notions of the Americans*, devised to encom-
pass all the representative features of the American landscape;
equally, it would defeat the compositional skill of even such
an allegorical landscapist as the later Thomas Cole to
reproduce the opening setting of *The Heidenmauer*, because
the lofty vantage point of the observer and the profusion and
variety of the artificial "parts" or "accessories" would com-

[40] William Gilpin, *Remarks on Forest Scenery*, 3d ed. (London: T.
Cadell and W. Davies, 1808), I: 263.

plicate beyond solution the problems of perspective and arrangement.

Cooper's prospects are generally less vivid than his landscapes and leave a less indelible impression in the reader's memory, and this is so not merely because of their extent but because, unlike his landscapes, they possess no single and unusual commanding feature. They are sufficiently distinct to serve the immediate purpose Cooper has in mind, which is to orient his reader, and they may be allowed to fade on the sight when that service is performed. For the storyteller, whatever clarity of profile prospects may lack is compensated for by the one characteristic that, in Thomas Cole's opinion, removed them from the landscape painter's province: they are "maplike."

2

The Picturesque Traveller

> You will smile at my old passion for fine skies and
> landscape scenery, but I have climbed to the castle
> of St. Elmo a dozen times within the past month
> to see the effect of the sunset.
>
> *Gleanings in Europe: Italy*

I

Cooper came to his maturity in an age that reverenced
landscape, in nature and in art, to such a degree that one
historian has designated the last three-quarters of the
eighteenth century as the Age of Landscape.[1] The appreciation
of landscape was a touchstone of sensibility, whether one
viewed nature metaphysically, as did Wordsworth, with the
"sense of something far more deeply interfused," or in a
narrowly aesthetic sense, like William Gilpin and his imitators,
who were interested primarily in developing a mode of seeing
rather than a mode of feeling and who consequently were ac-
cused of narrowing the scope of both taste and emotion in the
arts. "The romantic mind," says Christopher Hussey, "stirred
by a view, begins to examine *itself*, and to analyze the effects

[1] Christopher Hussey, *The Picturesque: Studies in a Point of View*
(London: G. P. Putnam, 1927), p. 96.

of the scenery upon its emotions. The picturesque eye, on the contrary, turns to the scene."[2] It is the same distinction Ruskin drew between the nobler picturesque and the surface-picturesque, the former, in Martin Price's phrase, "instinct with a moral awareness," the latter seeking "aesthetic patterns at the expense of moral sympathy."[3] Whatever allowances must be made for Cooper's occasional raptures in the presence of the sublime, whether in his accounts of travel in the Swiss Alps or in Natty Bumppo's hymns to his creator, he belongs most characteristically to the picturesque tradition as Hussey defines it. Not for him the inward turning eye. His sight is keen and active and, after the fashion of his age, amenable to training, but his moral responses to nature impress us, sooner or later, as conditioned reflexes.

The vogue of the picturesque, which began shortly before the middle of the eighteenth century and became, in Hussey's phrase, "the nineteenth century's mode of vision," had all but run its course in England by the time it was appropriated for the purposes of a nascent American art. Beginning in the 1780s, when the enthusiasm for romantic landscape took hold in the new republic, the term "picturesque" appears frequently in poetry, nature writing, and travel accounts, but its connotations are so unreliable that, as we have seen, even Cooper could employ it in a sense at once vague and indistinguishable from his use of the term "romantic." Hence the seven years that Cooper and his family spent abroad, between 1826 and 1833, are important not only because they confirmed certain tendencies in his social thinking but because they provided a kind of postgraduate course in aesthetics. The several books

[2] Ibid., p. 83.
[3] Martin Price, "The Picturesque Moment," *From Sensibility to Romanticism: Essays Presented to Frederick A. Pottle*, ed. Frederick W. Hilles and Harold Bloom (New York: Oxford Univ. Press, 1965), pp. 263–264.

that, following his return to Cooperstown, he culled from the letters and journals written during his travels were in large part a record of picturesque discovery.

The extent of Cooper's formal knowledge of art before 1826 cannot be documented very clearly. The record is mainly one of his associations with artists, particularly those of the Bread and Cheese Club, which he was instrumental in founding in 1822, and of his occasional self-deprecating remarks—reminiscent of Scott's—about the quality of his connoisseurship. "I am no judge of paintings," he wrote in 1823, "though I have seen hundreds of celebrated ones here and in Europe."[4] As late as 1832, at the height of his collecting period, he was still deferring to the judgment of his close friend, Samuel F. B. Morse, or admitting in a letter to William Dunlap that he is not yet, "thank Heaven, ass enough to believe I have the best taste" (though in the same letter he spoke of going to the Louvre to watch Morse at work on a portrait and to advise his mentor, with whatever admixture of facetiousness, how to paint).[5] Clearly, the New York years, from 1821 to 1826, must have laid the foundation of that interest in the arts—as they did for so many of his Knickerbocker contemporaries—which blossomed into Cooper's role as connoisseur, collector, and patron, during his residence in Europe.[6] The year before his departure from New York, his friend Morse had founded the National Academy of Design, which, by degrees, would usurp the position of the moribund American Academy of the Fine Arts; and in the same year Thomas Cole had arrived in New York from Philadelphia to begin his distinguished career. For some time he and Cooper

[4] James Franklin Beard, ed., *The Letters and Journals of James Fenimore Cooper* (Cambridge, Mass.: Belknap Press of Harvard Univ. Press, 1960), I: 95–96.

[5] Beard, *Letters and Journals*, II: 239.

[6] The New York art scene is recreated in detail by James T. Callow in his *Kindred Spirits*.

were neighbors in Greenwich Street while the latter was writing *The Last of the Mohicans*, but though they exchanged visits their friendship does not appear to have been close, and there is no record of an encounter during the subsequent years when both were in Europe. In contrast to Cooper's claim that he had seen hundreds of celebrated paintings, at home and abroad, Cole admitted in 1825, the year he first exhibited in the American Academy, that he had "never yet seen a fine picture of any foreign landscape,"[7] a remark that sheds light on the poverty of the American art scene and the narrowness of Cole's opportunities—disadvantages that Cooper would have surmounted in part through the superior privileges conferred by foreign travel and social position.

Aside from the informal education to be derived from his social and cultural pursuits, which would have included visits to the homes of art patrons and collectors, Cooper, like Cole, would have had to rely for native sources on what he could glean from the articles and engravings in such publications as *The New York Mirror* (1823–42) and the short-lived *New York Review* and *Atheneum Magazine* (1825–26),[8] the colored engravings in such infrequent and expensive volumes as William Guy Wall's *Hudson River Port Folio* (1824), the wares—not always authentic—of local picture-dealers, and possibly even the panoramas of American scenery that were being exhibited in New York by the third decade. Cooper's departure for Europe coincided with the first significant stirrings on the local art scene, and undoubtedly one of the expectations he carried abroad was that he would have now the opportunity to validate his credentials as collector, patron, and amateur critic of the arts.

"The first source of amusement for the picturesque

[7] Noble, *The Course of Empire*, p. 92.

[8] See Chapter II, "The Fine Arts in the Literary Magazines of New York," in James T. Callow, *Kindred Spirits*, pp. 92–102.

traveller," wrote that other indefatigable amateur, William
Gilpin, "is the *pursuit* of his object—the expectation of new
scenes continually opening and arising to his view."⁹ This is
the role in which Cooper explicitly viewed himself, and his
enthusiasm for fine scenery was shared by his family ("people
like ourselves," as he once described their party, "who were
out in quest of the picturesque").¹⁰ Abroad, he did all the cor-
rect things expected of the connoisseur: he was forever
descending from his carriage to take in a prospect, or con-
templating a site from different angles or at different seasons,
or commenting on his preference for views taken during the
ascent as opposed to those taken on the descent. He debates
with chance acquaintances the distinction between the *beau*
and the *pittoresque*. His connoisseurship developed so surely,
particuarly under the influence of Italian scenery, that by the
late summer of 1832, during the family's second visit to
Switzerland, he could write: "We are beginning to feel it is
vulgar to be astonished, and even in scenery, I think we rather
look for the features that fill up the keeping, and make the
finish, than those which excite wonder."¹¹ Their taste, that is
to say, was shifting its allegiance from the sublime to the pic-
turesque. Cooper's volumes of *Gleanings*, as well as such
romances as *The Headsman*, will have their occasional
testimonials, almost conventionally supplied, to the grandeur
and sublimity that the Swiss Alps had evoked from a century
of travellers; but by far the greater emphasis will be on the
cooler and more secular emotions associated with the ap-
preciation of the picturesque.

One trait of the connoisseur is that he is forever correcting

⁹ Gilpin, *Three Essays on Picturesque Beauty*, p. 47.
¹⁰ James Fenimore Cooper, *A Residence in France; with an Excursion
up the Rhine, and a Second Visit to Switzerland* (London: Richard
Bentley, 1827), II: 105.
¹¹ Ibid., p. 78.

nature's deficiencies, giving her, as Christopher Hussey remarks of Gilpin, "a lesson in deportment."[12] Nature, Gilpin had conceded, was masterly in design and an "admirable colourist," but seldom "correct" in composition: "Either the foreground, or the background is disproportioned: or some awkward line runs across the piece: or a tree is ill-placed, or a bank is formal: or something or other is not exactly as it should be."[13] He complained that when Farnham Castle was blown up during the Civil War, it was "not with that *picturesque judgment* with which many castles in those times were demolished,"[14] and he was so offended by the "regularity" of the gable-ends on Tintern Abbey that he recommended they be fractured "judiciously" with a mallet.[15] Cooper, viewing a scene as Gilpin did, animated by the picturesque faith, is sometimes guilty of the same presumption carried to amusing lengths: "All that the lakes of Switzerland need to render them faultlessly beautiful is islands."[16] Where they do appear, he adds, they are "insignificant, and not well placed," nor is there anything approaching "a grouping of islands." Similarly, of the Lake of Brienz: "An island or two would make it perfect."[17] Viewing a landscape along the road from Rouen to Paris, he remarks that "the play of light and shadow on these gay upland patches, though not strictly in conformity with the laws of taste, certainly was attractive."[18] On the subject of waterfalls, he suggests that "it is a defect with most great cataracts, that the accessories are seldom on a scale commensurate with the principal feature."[19] Though he

[12] Hussey, *The Picturesque*, p. 114.

[13] Gilpin, *Observations on the River Wye*, p. 31.

[14] Gilpin, *Observations on the Western Parts of England*, p. 38.

[15] Gilpin, *Observations on the River Wye*, p. 47.

[16] Cooper, *Sketches of Switzerland*, I: 169.

[17] Ibid., p. 221.

[18] James Fenimore Cooper, *Gleanings in Europe: France*, Robert E. Spiller, ed. (New York: Oxford Univ. Press, 1928), p. 82.

[19] Cooper, *Sketches of Switzerland*, I: 135.

generally restrained this tendency in himself, he allowed a freer license to his fictional characters. In Eve Effingham, for example, the impulse is as persistent and uncontrollable as a penchant for strong drink and its expression less tolerable; she is in fact a humorless echo of Peacock's Mr. Milestone.

Such presumption would have been perfectly understandable to the narrator of Poe's "The Domain of Arnheim," who argues that among all the arts the art of landscape alone can admit the notion of "improving" nature. "In the most enchanting of natural landscapes," he insists,

> there will always be found a defect or an excess—many excesses and defects. While the component parts may defy, individually, the highest skill of the artist, the arrangement of these parts will always be susceptible of improvement. In short, no position can be attained on the wide surface of the *natural* earth, from which an artistical eye, looking steadily, will not find matter of offence in what is termed the "composition" of the landscape.[20]

Consequently, only in the art of landscape (as opposed to portraiture and sculpture) is nature "to be exalted or idealized rather than imitated," for with her details—such as the color of a tulip, the proportions of a lily—"we shrink from competition." William Gilpin drew the same conclusion from a different perspective. Nature, he pointed out, works on a vast scale; the artist is "confined to a *span*" and must "adapt such diminutive parts of nature's surfaces to his own eye, as come within it's [sic] scope." He will rarely paint a good picture so long as he adheres to the composition of nature: "His picture must contain *a whole:* his archetype is but a *part.*"[21] Cooper is

[20] Edmund Clarence Stedman and George Edward Woodberry, ed., *The Works of Edgar Allan Poe*, (New York: Chas. Scribner's Sons, 1914), p. 117.

[21] Gilpin, *Observations on the River Wye*, p. 31.

seldom so explicitly concerned with the principles of taste, but he would have accepted the prerogative that such a rationale as Gilpin's provided to amend the natural landscape, both in his role as connoisseur in the travel books and as conscious artist in the romances.

One of the recurrent motifs that bind together the otherwise casual sketches of Switzerland is Cooper's dislike of John Bull in the guise of travelling Englishmen who go out of their way to derogate Americans; another is his sensitivity to violations of the picturesque mood; and when the two come together, his irritation surfaces. On a path near Unterseen he encounters a pretty English girl, momentarily detached from her tourist party, her bonnet dangling from a finger, her voice lifted in song. He bows; she fails to acknowledge the salute; and the incident provokes the following observation:

> The presence of strangers who appear to be engaged in *low-country pursuits*, mid such scenery, produces on me the impression of an unpicturesque reverence for nature. I had just left a spot, too, where a young Swiss had been in beautiful keeping with the scenery. There is a small meadow in a dale near the ruin. The last rays of the sun were streaming across it, and a pretty peasant girl, with disheveled hair, was raking together the scanty crop of grass. She was entirely alone, and seemed as innocent and as contented as she evidently felt secure. After all, she might have been out speculating on the picturesque, a suspicion that rudely obtruded itself when we met the English party.[22]

He is equally disturbed by the commercialization of the picturesque. When he praises the beauty of Lake Lucerne, his guide voices his preference for Lake Zurich with the phrase *"toujours des vignes"*—a sentiment that Cooper, with a wry appreciation of the old man's bias, translates into "Handsome

[22] Cooper, *Sketches of Switzerland*, I: 221–222.

is that handsome does."[23] Encountering along the road Swiss
children selling the local produce, he terms their enterprise "a
species of picturesque mendacity, which, while it did not
perhaps adorn, did not absolutely disfigure the character of
the scenery."[24] On learning that the lake of Sarnen is to be
partially drained, by means of a tunnel cut through rock, in
order to secure a thousand acres of new meadow, he protests
"this innovation on the picturesque," knowing as he does so
that his objection is futile: "In their eyes, a cheese is a more
beautiful object than a lake or a rock; and such, I apprehend,
is the governing rule for the appreciation of the sublime and
beautiful among the mass of mankind everywhere. A love of
the picturesque, unhappily, does not depend on the first wants
of nature, while the love of bread and cheese does."[25]

Finally, what is apparent in Cooper's observations in his
travel books is that he is viewing the landscape as much with
the gardener's as with the painter's eye, with an appreciation
of the close alliance between landscape painting and landscape
gardening which, though an aesthetic commonplace in
England since the time of Horace Walpole, was not at all active
in the America Cooper had left behind him. This is the topic
of the next chapter, but I should note in passing that at a time
when the art was in its infancy in America Cooper's interest in
landscape gardening probably antedated his interest in the fine
arts, and that had he chosen to exert himself in this direction
he probably was as qualified as Sir Walter Scott, the author of
the short treatise "On Landscape Gardening" (1828), to write
with authority on the subject. For the present, however, the
emphasis must be confined more narrowly to Cooper's vision
of landscape as picture, a vision clearly conditioned by his
knowledge of the European tradition of landscape painting,

[23] Ibid., II: 6.
[24] Ibid., I: 87.
[25] Ibid., p. 232.

particularly the Italian and English contributions, and of the theory of the picturesque, in both its general outline and its more incidental refinements.

II

The degree of Cooper's appreciation of individual landscape painters contemporary or deceased, cannot finally be determined. His travel books, and even his fiction, are a better source for inference than are his journals and letters, which are characteristically noncommittal on the subject of art in general and landscape painting in particular. His knowledge seems to have been as wide as his interest was active, but in the eight volumes of journals and letters there is only a handful of passing references to the great names in the tradition. Among the Americans only Thomas Cole and Washington Allston (whose "Elijah Feeding the Ravens" Cooper once contemplated purchasing) are cited. We know that he admired the Claudes in the National Gallery, where he also encountered some "detestable Poussins" whose authenticity he doubted; but in contrast to the travel books there is no mention of that other name so conventionally yoked with Claude's, that of Salvator Rosa. Aside from the glimpses of Cooper stalking the galleries and jotting down his unelaborated reactions or prowling the quais of the Seine in search of art bargains, the impression persists that he was most deeply engaged with society, politics, and the publication and sales of his books.

His travels in Italy provided scene after scene reminiscent of Claude and Salvator. The former's ideal landscapes—serene and golden, and evoking for the American the distinctive atmosphere of Italy as no other paintings did—seem to preside over Cooper's treatment of the Italian landscape in both his travel books and his fiction. The romancer has absorbed the seventeenth-century painter's vision and made it his own, and

it is everywhere active, if only by implication. Similarly with Salvator Rosa, whose rank and merits were controversial but whose influence was second only to that of Claude: Cooper in Italy was not surprised at any turn of the road to encounter Salvator's world of gloomy forests, wild rocks, and lurking banditti. En route from Bologna to Florence, via the Appenines, the Cooper party enters a region that "had a wildness and a character that, to us, were entirely novel" and subsequently meets "a swarthy, picturesque-looking peasant" who passes by "on a brisk trot, eyeing the carriage keenly as he went by."[26] The scene is drawn as if by Salvator, and the mood of apprehension with which Cooper invests the meeting will be utilized a few years later in a different context when Deerslayer and Chingachgook steal on the Mingo camp at night and discern Rivenoak "seated in the foreground of a picture that Salvator Rosa would have delighted to draw, his swarthy features illuminated as much by pleasure as by the torch-like flame." Claude may assist Cooper's romantic vision of Italy, but there is nothing in his art that the romancer can appropriate for his treatment of the primitive American landscape. Claude's landscapes, all harmony, proportion, gradation, and smoothness, lend themselves to the aesthetic of the Beautiful. The temples in his later landscapes, unlike the picturesque ruins Cooper found useful to his purpose, are intact; his verdure is tame; not wild; and the figures in his foregrounds, classically garbed and caught in attitudes of repose, are remote from Cooper's frontiersman and Indians in a way that Salvator's banditti are not. Salvator, in fact, provided an inspiration for later picturesque landscapists that was alternately praised and deplored. Gilpin, for obvious reasons, preferred him to Claude; Thomas Cole, although he painted his share of Salvatorean landscapes, reflected more accurately the taste of his period by reversing Gilpin's preference, rank-

[26] James Fenimore Cooper, *Gleanings in Europe: Italy* (Philadelphia: Carey, Lea, and Blanchard, 1838), I: 22.

ing Salvator below not only Claude but both the Poussins and
Ruysdael, and finding him, once he saw his paintings at first
hand, "peculiar, energetic, but of limited capacity com-
paratively."[27]

Long before Cooper's time the contrast between Claude and
Salvator had become a commonplace of aesthetic debate.
Typical are the observations of Mr. Seymour, the prentice
connoisseur in Uvedale Price's "A Dialogue on the Distinct
Characters of the Picturesque and the Beautiful," as he con-
templates a Salvator landscape:

> . . . There is a sublimity in this scene of rocks and moun-
> tains savage and desolate as they are, that is very striking:
> the whole, as you say, is a perfect contrast to the Claude;
> and it is really curious to look from the one to the other. In
> that, everything seems formed to delight the eye, and the
> mind of man; in this, to terrify the imagination: in the
> Claude, the inhabitants inspire us with ideas of peace,
> security, and happiness; in this of Salvator . . . "Each figure
> boldly pressing into life,/ And breathing blood, calamity,
> and strife." In that sweet scene, the recesses amid fresh
> woods and streams, seem bowers made for repose and love;
> in this, they are caves of death, the haunts of wild
> beasts. . . . [28]

In short, Salvator, with his bold pencil and vigorous concep-
tions of wild and savage nature, appealed to the imagination;
Claude, with his harmonious landscapes, to the quiet mind.
Salvator's landscapes became the archetypes alternately of the
Sublime and the Picturesque; Claude's, of the Beautiful.
Uvedale Price's American disciple, Andrew Jackson Downing
(to whom Cooper pays tribute in *The Redskins*), in his

[27] Noble, *The Course of Empire*, p. 171.

[28] Uvedale Price, *Essays on the Picturesque, As Compared with the
Sublime and the Beautiful; and, on the Use of Studying Pictures, for the
Purpose of Improving Real Landscape* (London: J. Mawman, 1810), I:
308–309.

Treatise on the Theory and Practice of Landscape Gardening
(1841), draws the conventional and by then commonplace dis-
tinction:

> To the lover of the fine arts, the name of Claude Lorraine
> [sic] cannot fail to suggest examples of beauty in some of its
> purest and most simple forms. In the best pictures of this
> master, we see portrayed those graceful and flowing forms
> in trees, foregrounds, and buildings, which delight so much
> the lover of chaste beauty—compositions emanating from a
> harmonious soil, and inspired by a climate and a richness of
> nature and art seldom surpassed.
>
> On the other hand, where shall we find all the elements
> of the picturesque more graphically combined than in the
> vigorous landscapes of Salvator Rosa! In those rugged
> scenes, even the lawless aspects of his favorite robbers and
> banditti are not more spirited, than the bold rocks and wild
> passes by which they are surrounded.[29]

Useful as the distinction was, and particularly for
separating "natural" from "artificial" landscape, the beautiful
and the picturesque tended, however, both in theory and prac-
tice, to combine. Uvedale Price, who established the pic-
turesque as a third category with the beautiful and the sub-
lime, argued that it held a station midway between these
opposites and concluded that for this very reason it "perhaps
is more frequently, and more happily blended with them
both."[30] This was, in fact, the view widely held by
landscapists, whether they were painters, gardeners, or writers
of prose romances. The picturesque could shade into the
beautiful on the one hand or into the sublime on the other.
"The limbs of huge trees shattered by lightning or

[29] Andrew Jackson Downing, *A Treatise on the Theory and Practice
of Landscape Gardening, Adapted to North America; with a view to the
Improvement of Country Residences*, 4th ed. (New York: G. P. Putnam,
1850), p. 65.
[30] Price, *Essays on the Picturesque*, I: 68.

tempestuous winds," remarks Price, "are in the highest degree picturesque; but whatever is caused by those dreaded powers of destruction, must always have a tincture of the sublime."[31] The freedom with which the aesthetic categories could be combined explains not only why the simple distinction between Claude and Salvator in the passages from Price and Downing are refined in other contexts so as to make Claude's landscapes exhibit the supreme blend of the picturesque and the beautiful and Salvator's that of the picturesque and the sublime, but also why Cooper, exploring a height above Sorrento and striving to express his sense of this unfamiliar landscape, can write: "One looks abroad here, in the full security of beholding objects that are either beautiful or sublime, and commonly both, for the two are so blended as to render it doubtful which most prevails."[32] A prospect could be viewed under the aspect of the beautiful by reason of its gentle outlines and harmony of detail, and under the aspect of the sublime by reason of its extent.

Neither in his travel books or in his fiction did Cooper hold very rigidly to the aesthetic categories. Like Uvedale Price, he seems to regard the picturesque as occupying a position in the scale midway between the beautiful and the sublime and consequently allying itself without difficulty to either: to the former, for example, when he is describing the park-like character of certain Swiss landscapes and the "neatness" (a term associated with the beautiful) of the cottages and their environs in the context of an otherwise picturesque setting;[33] to the latter, frequently, when he is describing a prospect view, as in the opening chapter of *The Pathfinder*. The neighborhood of Berne is "both beautiful and picturesque," for "the country is broken, but cultivated like a garden, and so well

[31] Ibid., p. 57.
[32] Cooper, *Gleanings in Europe: Italy*, I: 233.
[33] Cooper, *Sketches of Switzerland*, I: 35.

weeded as to resemble a vast park."[34] Or he will take note in
his travels across France of "an insignificant hamlet, of unex-
ceptionable neatness, and even of picturesque beauty."[35]
What also seems evident from such passages is that Cooper is
viewing the scene simultaneously as picturesque traveller and
landscape gardener, and it is not always clear which role is
dominant.

There is also the problem inherent in Cooper's method of
transmuting his observations, after a long interval, into print.
If we examine his journals, where he stored his impressions
for future use and from whose bare entries he later worked up
the more elaborate descriptions in his travel books, we are
struck by the absence of aesthetic terms. This would imply
that in writing his books Cooper would in large part have to
rely on memory and imagination not only to recreate his
scenes but to define them in terms of the appropriate aesthetic
categories. The journals consist simply of notes, jottings, set
down in haste and conveying only the most generalized pic-
tures; they contain the details from which he worked up his
sketches. In fact his method is roughly analogous to that of
the landscape painter, who selects, combines, and elaborates
his preliminary sketches in the finished composition, rearrang-
ing the "real" elements in the design of the "ideal" landscape.
"He who would paint compositions, and not be false,"
Thomas Cole wrote to his patron, Robert Gilmor, in 1825,
"must sit down amid his sketches, make selections, and com-
bine them . . . Such a course embraces all the advantages in
painting actual views, without the objections."[36] Cooper,
writing of Cole's art in *Notions of the Americans* three years
later, endorsed this method. "To me his scenery is like the
scenery from which he drew," he wrote, adding, however,

[34] Ibid., p. 56.
[35] Ibid., p. 34.
[36] Noble, *The Course of Empire*, p. 93.

that "he has taste and skill enough to reject what is dis-agreeable, and to arrange the attractive parts of his picture."[37]

To put the matter another way, Cooper's journals assert the tyranny of the eye, the immediacy and importunity of the actual, whereas the pictures he drew from them for his travel books reflect the idealizing tendency of the imagination—as to a greater degree do the more ambitious and functional landscapes of his fiction. It is a distinction to which Cooper frequently alludes. "I despair," he writes, in *Sketches in Switzerland*, to an unidentified correspondent, "of making you see Lauterbrunnen through the medium of the mind's eye; still you shall have the elements of this remarkable valley, to combine in such a picture as your own imagination can draw."[38]

III

Among the European countries he visited, Cooper had decided preferences. England appealed to him least and France only intermittently. "Whatever may be said of the beauty of the country in England, in particular parts," he wrote, "it scarcely merits its reputation as a whole. I have seen no portion of it that is positively ugly, a heath or two excepted, and yet I have seen more that is below mediocrity than above it."[39] His impressions were based on three short visits to England, one at the beginning of his European sojourn, one at the end, and one, mainly social, extending over three months in 1828. On none of these occasions did he see more of the countryside than was visible from the coach carrying him to and from London and the various ports or than could be seen in excur-

[37] Cooper, *Notions of The Americans*, II: 157.

[38] Cooper, *Sketches of Switzerland*, I: 83.

[39] James Fenimore Cooper, *Gleanings in Europe: England*, Robert E. Spiller ed., (New York, Oxford Univ. Press, 1930): 212.

sions outside the capital. The one surviving letter from his first visit conveys only the excitement of the traveller determined after years of confining domesticity to enjoy himself to the fullest ("I confess, although somewhat travelled before, I enjoyed these old remains of other days, with as much gusto as though I had been fresh from the *new* scenery of home, for the first time").[40] But by the time he came to write his travel books his evaluation of scenery had been conditioned by the grander and more vivid effects of the Swiss landscape. The prevailing character of the English landscape he described as *petite*, "by which I would portray narrow vales, low swells, and limited views," and its appeal for a visiting American was, like that of other European countries, in its finish, its associations, and "a certain air of rural snugness and comfort."[41] Compared to that of Switzerland, the landscape was too small in scale, too clipped, too tame.

As for France, Cooper's general verdict seems out of line with his appreciation of the country's particular charms. Although he was persuaded "that few countries offer less to the eye of the mere passer-by than France; the tastes of the people being little given to the picturesque,"[42] the observation was made in the context of his disappointment with Provence ("a less attractive region than that we drove through is seldom seen"). Elsewhere, along the route from Rouen to Paris or on the Seine about thirty miles from Havre, the appearance of the country strikes him as ranging from "exceeding pretty" to "extraordinary."

But it is Switzerland that generates his first real enthusiasm and stimulates the picturesque vision. England for society, Switzerland for scenery: this is the clear inference to be drawn from Cooper's record of his visits. A single statement sum-

[40] Beard, *Letters and Journals*, I: 147.
[41] Cooper, *Gleanings in Europe: England:* 12.
[42] Cooper, *Gleanings in Europe: Italy*, I: 100.

marizes his impression of Switzerland: "We soon entered and passed the village of Unterseen, which has a thoroughly Swiss, and, consequently, a truly picturesque character."[43] There are moments, rather fewer than might be expected, when he works himself into the sublime mood, as on first sighting Mont Blanc and experiencing "a feeling allied to the universal love of the mysterious that causes us all to look with pleasure at any distant object which insensibly leads the mind to the contemplation of things that are invisible,"[44] but generally his taste is for the "wild gorges" whose heights are crowned with the picturesque ruins of castles, or for the hedges around Berne, "a feature that is usually wanting in the continental picturesque,"[45] or for the "picturesque little stone bridges of single arches" spanning the Aar, which "were designed by a painter, though the man never saw a pencil."[46]

In October, 1828, the Cooper party set out from Switzerland for Italy. As they descended to the plain of Lombardy, Cooper later wrote, they perceived they had taken leave of grandeur and were "now in a country that was *beau*, in the sense of the Frenchman, without being *pittoresque*."[47] Apparently he was referring not to Italy as a whole but to the flat landscape of Lombardy, for Italy, along with Switzerland, would prove to have its share of picturesque attractions. From Bologna to Florence, through the Apennines, the character of the scenery changed dramatically: "The region we were now in had a wildness and a character that, to us, were entirely novel. . . . I can best compare the view to the back-grounds which the old Italian masters sometimes put to their religious subjects, and of which treeless hills, rocks, winding paths, and picturesque towers compose the materials."[48]

[43] Cooper, *Sketches in Switzerland*, I: 81.
[44] Ibid., p. 27. [45] Ibid., p. 56.
[46] Cooper, *Sketches of Switzerland*, II: 114–115.
[47] Ibid., p. 232.
[48] Cooper, *Gleanings in Europe: Italy*, I: 21.

As it turned out, Italy, where the Cooper family spent a year and a half, was the fulfillment of a dream, and Cooper, in his Italian *Gleanings*, evokes a series of dream-like landscapes. It was the climax, moreover, of that education of the senses that had advanced so rapidly since his arrival in Europe. "Switzerland astonishes," he wrote, "and it even often delights, by its union of the pastoral with the sublime; but Italian nature wins upon you until you come to love it like a friend."[49] His enthusiasm led him to praise each successive view along the peninsula as the finest he had ever seen. But it was on the passage to Ischia that the unique quality of the Italian landscape—that "refinement" of nature that distinguished it from other countries "as the same quality distinguished the man of sentiment and intellect from the man of mere impulses"—revealed itself in a moment and a scene perhaps not adequately individualized by Cooper's later account:

Having opened the channel between the two islands, we bore up for the town of Ischia, where we arrived a little before sunset. Here a scene presented itself which more resembled a fairy picture than one of the realities of this everyday world of ours. I think it was the most ravishing thing, in its way, eye of mine ever looked upon. We had the black volcanic peaks of the island for the background, with the ravine-like valleys and mountain-faces, covered with country houses and groves, in front. The town is near the southern extremity of the land, and lies along the shore for more than a mile on a bit of level formation; but, after passing a sort of bridge or terrace, which I took to be a public promenade, the rocks rose suddenly, and terminated in two or three lofty, fantastic, broken fragment-like crags, which

[49] Ibid., p. 215.

make the south-eastern end of the island. On these rocks
were perched some old castles, so beautifully wild and pic-
turesque, that they seemed placed there for no other pur-
pose than to adorn the landscape. . . . Until that moment I
was not fully sensible of the vast superiority of the Italian
landscape over all others.

Other scenes, he continued, have "the tints, the hues, the out-
lines, the proportions, the grandeur, and even the softness of
beauty; but these have the character that marks the existence
of a soul."

The effect is to pour a flood of sensations on the mind, that
are as distinct from the commoner feelings of wonder that
are excited by vastness and magnificence, as the ideas
awakened by an exquisite landscape by Claude are different
from those we entertain in looking at a Salvator Rosa.[50]

Cooper is transcendently moved by the fusion of landscape
and mood that seems the especial product of the Italian at-
mosphere. And that atmosphere is characterized by the om-
nipresent haze over the landscape, which has for him the
effect of removing the scene from the actual and present.
Cooper has the picturesque passion for misty effects—"my
beloved mist" is a frequent refrain in his *Gleanings*. An eve-
ning view of the Eiger, near Interlaken, provokes an un-
characteristic mood of rapture: "Mist-mist-mist—give me mist
for scenery. Natural objects are as much aided by a little of
their obscurity and indistinctness as the moral beauties of man
are magnified by abstaining from a too impertinent in-
vestigation."[51] How "aided" is suggested by his postscript to a
description of the valley of Meyringen: "The mist was stir-
ring, softening all, and keeping curiosity alive."[52] In Italy he is

[50] Ibid., pp. 214–215.
[51] Cooper, *Sketches of Switzerland*, I: 99.
[52] Ibid., p. 104.

struck repeatedly by the "hazy" Apennines, the "misty" Apennines, and particularly by that indispensably picturesque effect of contrasting light and shade, which "rendered them pictures to study."[53]

"Haziness," William Gilpin had written, "has often a good effect in a picturesque scene. The variety of objects, shapes, and hues which compose an extensive landscape, though inharmonious in themselves, may be harmoniously united by one general tinge spread over them."[54] It may, in short, provide a natural principle of unity in the composition. It may also, by casting a dreamy atmosphere over the scene and softening the contrast of light and shade, persuade the actual to yield its substance and outline to a vision of the ideal landscape. "A morning mist drawing a slender veil over all objects," wrote William Hazlitt, "is at once picturesque and *ideal:* for it in the first place excites immediate surprise and admiration, and in the next a wish for it to continue, and a fear lest it should be too soon dissipated."[55] Hazlitt's use of "veil," together with Cooper's emphasis on the value of "indistinctness," recalls another admirer of ideal landscape. Poe, who defined art as "the reproduction of what the Senses perceive in Nature through the veil of the soul," and who would discount the evidence of the "naked Senses," had his own prescription, as effectual as mist, for visualizing the ideal landscape. "We can, at any time," he insists, "double the true beauty of an actual landscape by half closing our eyes as we look at it."[56] It is evident, at any rate, that in Cooper's passion for mist we have another instance of his adopting, in concert

[53] Cooper, *Gleanings in Europe: Italy*, I: 136.

[54] Gilpin, *Observations on the Western Parts of England*, p. 161.

[55] William Hazlitt, *Table-Talk, or, Original Essays* (London: Henry Colburn and Co., 1822), II: 378.

[56] The remarks appear under the rubric "Art" in Poe's *Marginalia*. See Stedman and Woodberry, *The Works of Edgar Allan Poe*, VII: 276–277.

with his romantic contemporaries, a conventional picturesque attitude.

Predictably, another high moment—or succession of high moments—occurred when Cooper looked down from the heights on the Bay of Naples, that "parent," as Christopher Hussey has dubbed it, "of all Ideal Landscapes."[57] Cooper's single journal entry conveys little of the observer's feeling or of the special quality of the prospect. "Absurdity of comparing the bays of New-York and Naples," he noted. "That of Naples infinitely the most imposing by its mountains, by the play of light and shade on their sides, and by its associations, while the latter is in every respect superior as a port by its facilities and its being landlocked."[58] In retrospect, however, the picture acquired a Claudian charm:

> The bay itself was asleep, with its bosom dotted with a thousand boats, and crafts of different sizes. The deathlike calm that pervaded everything was in exquisite accordance with the character of the entire view. The mountains were dreamy, the air was filled with a drowsy repose, while the different objects of historical interest over which the eye rather lingered than glanced, gave the whole the semblance of a physical representation of things past, adorned and relieved by a glorious grouping of so much that is exquisite in the usage of the present.[59]

The thousand boats, with their listless, drooping sails, include nearly every rig known to this "picturesque sea," and the whole picture—boats, water, coast, and the artificial accessories that Cooper has enumerated in an earlier passage, the "palaces, villas, gardens, towers, castles, cities, village churches, convents and hamlets, crowded in a way to leave no point fit

[57] Hussey, *The Picturesque*, p. 85.
[58] Beard, *Letters and Journals*, I: 379.
[59] Cooper, *Gleanings in Europe: Italy*, I: 181.

for the eye unoccupied, no picturesque site unimproved"—is invested with "a seductive ideal, that blended with the known reality in a way that I have never before witnessed, nor ever expect to witness again."

Even so, Cooper has by no means exhausted his capacity for responding in superlatives to the Italian scene. En route from Genoa to Nice, along the Grande Corniche of the Maritime Alps, it occurs to him that "imagination cannot portray bits of scenery more picturesque than some that offered on the beach,"[60] with its wild ravines spanned by ancient stone bridges. When shortly afterward Monaco comes into view, he redoubles his enthusiasm: "The whole of this coast is as picturesque and glorious, however, as the imagination can paint."[61] The coast of southern Italy is no less superb. A prospect of the beach at Sorrento furnishes "the prettiest bit of scenery, in its way, I have ever met with; nor do I remember any picture that surpasses it."[62] And of Capri he writes: "The picturesque seems exhausted in such beautiful spots."[63] To say that Cooper's visual memory, when he came to write his books, proved inadequate to his task, and that his raptures found no answerable style, is true enough on this occasion, but not generally true. The Italian *Gleanings*, like his other travel volumes, is carelessly—which is to say, artlessly—written. It is also rather devoid of human interest and of Cooper's usual absorption in political and social phenomena. But it has one virtue conspicuously lacking in its companion volumes: the author is more frequently willing to relax his habitually severe mood and to surrender himself to the enjoyment of scenery and the chance encounter.

From his European experience as a whole, but particularly

[60] Ibid., p. 90.
[61] Ibid., p. 93.
[62] Ibid., p. 200.
[63] Ibid., p. 223.

from his travels in Italy, Cooper drew certain invidious con-
clusions (which he never modified) about the scenery of his
native land. The Grand Duke of Tuscany, Leopold II, seemed
surprised, Cooper reported, "when I told him that we had no
scenery to compare with that of the Mediterranean."[64] Nearly
all of the American coast, he told the Duke, was "tame and
uninteresting," the lakes were either too large so that they
resembled the ocean or, if small, they were unequal in beauty
to those of Switzerland and Italy, and the mountains were
"much inferior to those of Tuscany, even." He admonished
the readers of *Gleanings*, in what was to become a
characteristic argument:

> I am very far from underrating the importance of fine
> natural scenery to a nation; I believe it not only aids
> character, but that it strengthens attachments. But calling a
> second-rate, or an inferior thing, a first-rate and a superior,
> is not making it so. There is, in America, enough of
> beautiful nature, coupled with the moral advantages we
> enjoy, to effect all necessary ends, without straining the
> point to the absurd; but there is very little of the grand, or
> the magnificent.[65]

Cooper might remark cautiously of a stretch of road between
Utica and Cooperstown that it "comes almost up to the level
of what would be thought fine rural scenery even in
England,"[66] but he could not rise to the mood of his com-
patriot, Thomas Cole, who, travelling in Italy in these same
years, could write home: "I have found . . . no natural scenery
yet which has affected me so powerfully as that which I have
seen in the wilderness places of America."[67]

In fairness, however, it should be added that Cooper's judg-

[64] Ibid., p. 70.
[65] Ibid., p. 155.
[66] Cooper, *Gleanings in Europe: England*: 212.
[67] Noble, *The Course of Empire*, p. 142.

ment was determined not so much by the dryness of his temper or his aversion to the slightest expression of Yankee chauvinism as by the recognition, widely shared in his time, of Europe's advantage in its history and architecture, and of the superior charm and interest imparted to the landscape by its associations and artificial accessories. In America, the majority view is conveniently summarized by William Tudor, who, in the same year Cooper published his first novel, observed: "Our picturesque objects of an artificial kind are vastly fewer than those in older countries. The total absence of ruins deprives us of what is an abundant source of associations in Europe. No artist could be reconciled to this deficiency. . . . "[68] A more sanguine view, and one which is closer to Cooper's, is that of Robert C. Sands, who, conceding that "our national associations are few," nonetheless insisted that "the local associations are many, and of deep interest."

> Some of them, too, are beginning to assume the rust of an-
> tiquity. They have arrived at a respectable old age, being
> quite beyond the memory of living men, and therefore
> affording scope for the imagination; while they are not, on
> the other hand, so hidden in the shadows of past days as to
> lose the charm of personal interest.[69]

Even Thomas Cole, for all his partisan devotion to the natural scenery of his adopted country, conceded its limitations. Returning from an excursion into "a wild secluded scene" in the Catskills, he confided to his journal: "Simple nature is not quite sufficient." Although American scenery was often "so fine," he wrote, "we feel the want of associations such as cling to scenes in the old world. . . . We

[68] William Tudor, *Letters on the Eastern States*, 2nd ed. (Boston: Wells and Lilly, 1821): 322.

[69] Robert C. Sands, "Domestic Literature," in *The Writings of Robert C. Sands* (New York: Harper and Bros., 1835), I: 103.

want human interest, incident, and action, to render the effect of landscape complete."[70] (This only six years after he had exulted in the fact that "All nature here is new to art.") Cole's remarks echo the theme of one of the great debates in the critical journals of the period: the present shape and future development of the historical romance in America. Had he been writing about the romance instead of landscape, his sentiment would have been equally pertinent. That the genre had no raison d'etre in the America of Cooper's time was a notion difficult to counteract. It persisted, in fact, into the beginning of the next century. "Nature in Cooper," wrote W. C. Brownell (1906), "counts as romantically as she does in Scott, but it is nature without memories, without monuments, without associations."[71] This is an egregious overstatement but one which Cooper would have understood and, in the sense that it expressed the particular frustration of the historical romancer in America, would have endorsed, in spite of the fact that one of the conscious aims of his art would be to exploit whatever associations were available in order that one of the benefits of his indigenous romances would be to enhance the legitimacy of these associations for later writers.

Under the immediate spell of Europe, however, he could only advert time and again to the comparative poverty of the American setting, particularly with regard to its artificial accessories, and, wherever in Europe he detected the precedence of utility over taste, deplore the more widespread evidence of that tendency at home. The picturesque charm of the domestic architecture along the Neapolitan coast brought to mind the "Grecian monstrosities" and "Gothic absurdities in wood" of Manhattan,[72] and he could conclude his descrip-

[70] Noble, *The Course of Empire*, p. 294.

[71] W. C. Brownell, *American Prose Masters*, Howard Mumford Jones, ed., (Cambridge, Mass.: The Belknap Press of Harvard Univ. Press, 1967), p. 12.

[72] Cooper, *Gleanings in Europe: Italy*, I: 154.

tion of the ancient stone bridges spanning the Aar in
Switzerland with the lament that "there is not such a bridge as
either of these . . . in the whole of matter-of-fact, utility-
loving, and picturesque-despising America!"[73] Disagreeably
impressed by the "common-place and dirty road, among
forges and mills" that led to the cataract of the Rhine ("What
accessories to a cataract!"), he contemplated the future of his
own country: "How long will it be before the imagination of a
people who are so fast getting to measure all greatness,
whether in nature or art, by the yard-stick, will think of these
embellishments for Niagara!"[74] Enchanted, as only a one-time
sailor could be, by the variety of sailing vessels along the
Mediterranean coast—"the felucca, the polacre, the xebec, and
the sparranara"—he is reminded of "the utilitarian quality of
our own vessels," and concludes: "I do not believe we are
without poetic feeling as a people; but we are sadly deficient in
the ordinary appliances of the art."[75]

One of the elements in the American landscape that most
offended the picturesque eye was the white paint lavished on
domestic structures. As James Callow has indicated, both
Cooper and Nathaniel Parker Willis mounted private cam-
paigns against this abomination, as did Andrew Jackson Dow-
ning. Uvedale Price, however, was not necessarily the
"source," as Callow suggests, of their prejudice; the animus
against white, in natural scenery as well as artificial
accessories, had been a conditioned response in the literature
of the picturesque from the time of Gilpin. "Pure white," the
latter had declared in his poem "On Landscape Painting,"
"great nature wishes to expunge/ From all her works."[76]
Gilpin's essays are filled with animadversions on the white

[73] Cooper, *Sketches of Switzerland*, II: 115.

[74] Cooper, *A Residence in France*, II: 53.

[75] Cooper, *Gleanings in Europe: Italy*, I: 52.

[76] Gilpin, *Three Essays on Picturesque Beauty*, p. 343.

blemishes in landscape, for example the exposed chalk of the downs (he will admit chalk cliffs only when nature has draped them with "samphire and other marine plants") and the white paint on Welsh farmhouses, "which gives them a disagreeable glare."[77] He will grant that a small building painted white may be an advantage in a view, "but when these white spots are multiplied, the distinction of their colour detaches them from the other objects of the scene, with which they ought to combine."[78] Cooper is no less emphatic in his prejudice—"As a standing colour," he declares, "I think it is one of the worst that can be introduced into scenery"—but he supplies an additional rationale. "I seldom look at a white wooden edifice with satisfaction," he writes in *Sketches in Switzerland*. "The idea of the perishable nature of the material, and, as an inseparable consequence, of meanness, invariably arises to destroy it." The Swiss cottage, built of larch, is an exception, but this he attributes to "the fitness of the subdued color of the resin to the thing; to association, which, in this instance, requires extreme simplicity." But "the same cottage, painted white," he is persuaded, "would be found offensive and obtruding."[79] White fences fall under the same prohibition. Cooper's Miles Wallingford complains that they give "the prettiest landscape the air of a bleaching yard, or a great laundry."

To sum up the indictment as it is set forth in the travel books: American scenery, compared with European, is tame; the associations are few and insufficiently hallowed; and the artificial accessories reflect a utilitarian and therefore paramount bad taste.

Beginning with *Homeward Bound*, Cooper permitted his fictional characters to assume his role as aesthetic commen-

[77] Gilpin, *Observations on the River Wye*, pp. 94–95.
[78] Gilpin, *Observations on the Western Parts of England*, p. 157.
[79] Cooper, *Sketches of Switzerland*, II: 78–79.

tator—provided, of course, that their backgrounds and education qualified them for the assignment—as if to give his views the wider currency of fiction. Their collective observations cover the same ground, and almost in the same detail, as the travel books, but because of the incompatability of the narrative and dramatic context they range in effect from the ludicrous to the simply irrelevant. When Corny Littlepage (*Satanstoe*) observes of the prospect view of Lake George, "From what I have read and heard, I am now fully aware that the grandest of our American scenery falls far behind that which is to be found among the lakes and precipices of the Alps, and along the almost miraculous coast of the Mediterranean," we know that we are listening to Cooper rather than to a young man who has been travelling through enemy-infested wilderness to join a military adventure; and the echo may be traced to the same source when we hear Hugh Littlepage (*The Redskins*), who is a veritable compendium of his creator's sentiments and opinions, descant on the native scenery: "Our New York landscapes are rarely, nay, never grand, as compared with the noble views one finds in Italy, Switzerland, Spain, and the finer parts of Europe; but we have a vast many that want nothing but a finish to their artificial accessories to render them singularly agreeable." These are gratuitous asides which merely reinforce the impression of Cooper's fatal discursiveness. But occasionally the connoisseur impulse plays havoc with the already frail credibility of Cooper's narrative situations, as when Eve Effingham, clinging to the ship's rail during an Atlantic storm, urges her companion to "forget the danger, and admire the sublimity of this terrific panorama," or when Major Willoughby (*Wyandotté*), stationed at a lookout and cut off from rescue during the attack on the Hutted Knoll, turns, in this moment of great danger, to his beloved Maud Willoughby and remarks, "This is a *coup d'oeil* not to be despised."

Among Cooper's fictional ventriloquists, it is Eve Effingham, that "ardent admirer of nature," who is called upon most frequently to harry the reader with her superior taste. On the passage home, in *Homeward Bound*, her opportunities are limited, for on the level of natural description this is one of Cooper's most ambitious efforts to evoke the sublime, and since the sublime, as Hugh Blair defines it, "is the offspring of nature, not of art," the connoisseur is necessarily limited in the range and variety of his response. The setting of all but the final pages of *Homeward Bound* is either the vast Atlantic or "the solitary and gloomy grandeur" of the coast of north Africa, with its "sublime sterility" ("for even naked sands," Cooper adds, "may become sublime by their vastness"). The result is that Miss Effingham is compelled to fall back rather too frequently and monotonously on the limited vocabulary she can summon to express the sublime. On the other hand, when the ship enters the Bay of New York she can rely on a cozier frame of reference: "These smaller vessels are less picturesque than those I have been accustomed to see." And once on shore, in *Home as Found*, she can dazzle the folk with her European education—a Cooper in petticoats whose authority in all matters pertaining to taste and manners receives the patient deference not always granted her creator.

Homeward Bound and *Home as Found*, both published in 1838, mark Cooper's return to the native setting for his fiction. They follow his travel books and consequently, as might be expected, reflect his altered vision of the landscape as well as of his countrymen's politics and manners. Increasingly from now on, American nature and its accessories will be brought under the trained eye, and Cooper's fiction will have to adjust to the burden of his acquired culture as well as his social and political antipathies.

But he will also employ his connoisseurship to impress on his countrymen the importance of taste in distinguishing the

gentleman. This is the emphasis that Norman T. Newton, the historian of landscape architecture and decidedly no admirer of Uvedale Price, Richard Payne Knight, and that "almost exclusively literary cult" of landscape they founded, detects in the writings of their American follower, Andrew Jackson Downing, the tone of whose treatise, according to Newton, is determined by a pervasive status-consciousness. "In effect," he argues, "one was continually urged, though often by subtle implication only, to show that one belonged, so to speak, on the right side of the tracks—that one was of the 'imaginative and cultivated few' who were capable of 'refined enjoyment' because they had 'cultivated and refined minds.'"[80] Newton's account of the aesthetic controversy and of early nineteenth-century developments in landscape gardening is marked by obstinate scorn not only for "mere verbal metaphysics," the "sentimental 'wiggly Nature' school," and "the 'wild improvers' of the Price–Knight cult," but for the romantic spirit in general, and particularly in its literary manifestations. He makes no allowance for the fact that Downing, in a period when landscape gardening had as yet no wide acceptance, was employing the basic marketing appeal of emulation in order to sell his services, and he does less than justice to the Downing who also expresses the hope that his book will be useful to the reader of limited means "who has only three trees to plant for ornament."[81] But he has touched on a motive that links Downing, the professional landscapist, with Cooper, the type of the prospective client to whom the former must direct his argument, the landed proprietor whose possessions ought to reflect his stake in society, the American gentleman who yields

[80] Norman T. Newton, *Design on the Land: The Development of Landscape Architecture* (Cambridge, Mass.: The Belknap Press of Harvard Univ. Press, 1971), p. 263.

[81] Downing, *A Treatise on the Theory and Practice of Landscape Gardening*, p. 20.

to no one in his allegiance to aristocratic principles of taste and decorum so long as they do not derive their authority from a monarchical form of government. The Cooper who lectures his countrymen on taste and manners as well as social and political ideals is mainly the Cooper of the Effingham and Littlepage chronicles, but the continuity of his literary personality is felt even in the forest romances when, as frequently is the occasion, he must distinguish between his own perception of a scene and that of his less civilized characters ("As he approached the building of old Hutter, Deerslayer thought, or rather *felt*, that its appearance was in singular harmony with the rest of the scene" . . . "Nevertheless, the whole was lost on the observers, who knew no feeling of poetry" . . . "Most of this scene too was lost on Hutter and Hurry"). When Major Willoughby, in that moment of great danger in *Wyandotté*, exclaims "This is a *coup d'oeil* not to be despised," he is not merely exhibiting self-possession; he is quite simply flaunting his connoisseurship.

❦ 3

The Landscape Gardener

As Nelson once said, 'want of frigates' would be
found written on his heart were he to die, I think
'want of gardens' would be found written on
mine.

A Residence in France, II, 28

I

"God Almighty first planted a garden," wrote Francis Bacon,
"and, indeed, it is the purest of human pleasures." When in
1818 Cooper acquired a small farm in Westchester County,
near Scarsdale, New York, one of the avocations in which he
began to take the keenest pleasure was the improvement of his
grounds. It was, his daughter recalls,

> a task into which Mr. Cooper entered with instinctive good
> taste, and with all the animation and warmth of interest
> peculiar to his character. The position of the house was fine,
> commanding a beautiful view over the farms and woods of
> the adjoining country, in whose varied groves tulip and
> hickory-tree, cedar and sassafras, grew luxuriantly; a broad
> reach of Sound stretched beyond, always dotted with the
> white sails the sailor's eye loved to follow in their graceful
> movements to and fro, while the low shores of Long Island,
> with the famous pippin orchards of Newtown, formed the
> distant background. Planning a lawn, building a ha-ha

fence, then a novelty in the country, and ditching a swamp, were the tasks of the moment; while the friends who followed his movement often smiled at the almost boyish eagerness with which he watched the growth or shrubs, or they shook their heads sagely at the size of the trees he was engaged in transplanting.

The art of landscape gardening was then in its infancy in America. "English books had led the way," reports Susan Cooper, "returning travellers suggested new ideas, and people were beginning to talk about grouping trees, and shrubbery, and grading lawns."[1] Andrew Jackson Downing, when he wrote his *Treatise*, could recall only one previous American work on the subject, Bernard McMahon's *American Gardener's Calendar*, and it was primarily a planter's manual of seasons, fertilizers, and species.[2] Derek Clifford has found two advertisements, in issues of New York newspapers of 1768 and 1778, setting forth the credentials of emigré professional gardeners, but no indication that they enjoyed a clientele.[3] As Norman T. Newton indicates, there is almost no evidence, except in letters, descriptions, and nursery catalogues, on which to reconstruct eighteenth-century examples of landscape gardening in this country, although he concludes that "the internal structure of gardens, wherever they existed, was apparently a simple geometric arrangement of beds, usually rectilinear but on occasion circular, rather uniformly in all the colonies up and down the Atlantic seaboard."[4] In other words, the revolution in garden design that was taking place in mid-eighteenth-century England, characterized by the extension of the garden to include the

[1] S. F. Cooper, *Pages and Pictures*, pp. 14–15.
[2] Downing, *A Treatise on the Theory and Practice of Landscape Gardening*, 40.
[3] Derek Clifford, *A History of Garden Design* (London: Faber and Faber, 1962), pp. 202–203.
[4] Newton, *Design on the Land*, p. 247.

landscape, the deference to nature, and the concealment of art, had not reached these shores, and the colonists were, in their small way, continuing the tradition of the formal garden favored by the French and Dutch. This time lag persisted well into the nineteenth century. By the time the vigorous development in American landscape gardening got under way, in the fourth decade of the century, the great era of English landscape gardening had come to an end.

In America the only nineteenth-century practitioner of the art whose name (though little else about him) has come down to us is André Parmentier, a Belgian who arrived in this country in 1824 and in the following year established a botanical garden in Brooklyn. There he cultivated and propagated both foreign and domestic plants and trees, and, according to Downing, "gave a specimen of the natural style of the laying out of grounds, combined with a scientific arrangement of plants, which excited public curiosity, and contributed not a little to the dissemination of a taste for the natural mode of landscaping gardening."[5] The first professional landscape gardener on this side of the Atlantic whose activities can be documented, however scantily, Parmentier before his death in 1830 had laid out grounds and gardens for clients ranging from Canada to the Carolinas. With few native sources of instruction or encouragement, the American country gentleman who wished to improve his grounds would have had to rely on imported publications, notably the writings of Uvedale Price's disciple J. C. Loudon, whose influence historians of the art tend to deplore but to whose instruction Downing, in 1840, ascribed "much of what is known of the art in this country."[6]

[5] Downing, *A Treatise on the Theory and Practice of Landscape Gardening*, pp. 40–41.
[6] Ibid., p. 37.

The primitive state of the art toward the end of the eighteenth century is suggested by Cooper's description of Judge Temple's mansion and grounds in *The Pioneers:*

> It stood in the centre of an enclosure that included several acres, which were covered with fruit trees. . . . In addition to this show of cultivation, were two rows of young poplars, a tree but lately introduced into America, formally lining either side of a pathway, which led from a gate, that opened on the principal street, to the front door of the building.

As with the grounds, so with the house itself: the mansion, "large, square, formal," reflects the eccentric taste and amateur zeal of the owner's cousin, Richard Jones, and his collaborator, Hiram Dolittle. "Together, they had not only erected a dwelling for Marmaduke, but had given a fashion to the architecture of the country. The composite order, Mr. Dolittle would contend, was an order composed of many others, and was intended to be the most useful, for it admitted into its construction such alterations as convenience or circumstances might require." The incongruity of the architecture extends to the appearance of the grounds, for aside from the imported poplars and the new growth of willows about the house, the Judge's acres are still dotted with the unsightly stumps from the original clearing and by occasional "stubs," the fire-ruined trunks of once noble pines and hemlocks.

An interval of fifteen years separates the publication of *The Pioneers* from that of *Home as Found.* When the Effinghams in the latter novel return from their long residence in Europe, they find that John Effingham, in deference to picturesque taste, has altered the architectural style of the Mansion-house, now called the Wigwam, from the composite order to a modest form of Gothic and has made some effort to improve the grounds:

Although the wigwam now stood in the centre of the village, its grounds covered several acres, and were intersected with winding walks, and ornamented with shrubbery, in the well-known English style, improvements also of John Effingham; for, while the climate and forests of America offer so many inducements to encourage landscape gardening, it is the branch of art that, of all the other ornamental arts, is perhaps the least known in this country. It is true, time had not yet brought the labors of the projector to perfection, in this instance; but enough had been done to afford very extensive, varied, and pleasing walks. The grounds were broken, and John Effingham had turned the irregularities to good account, by planting and leading paths among them.

The improvements are essentially those that Cooper made shortly after his return from Europe in the ancestral house and grounds. As he wrote in the anonymous promotional guidebook, *The Chronicles of Cooperstown* (1838): "The 'Hall' having passed into the hands of J. Fenimore Cooper, Esq., that gentleman . . . had it extensively repaired and a good deal altered." The grounds, he added, "have also been enlarged and altered, the present possessor aiming at what is called an English garden."[7] Two decades after Cooper began his improvements, the English, or natural, style was still in evidence. Nathaniel Parker Willis, in his *Out-Doors at Idlewild* (1854), reproduces a letter from a friend who has lodged at the Cooper house, converted after the romancer's death into a summer boarding-house: "The grounds are also untouched, and are wild and extensive—bewildering one in a perfect labyrinth of serpentine walks and miniature forests; a tastefully constructed flower-garden, forming a pleasant supplement."[8]

[7] *The Chronicles of Cooperstown* (Cooperstown: H. and E. Phinney, 1838), p. 84.

[8] Nathaniel Parker Willis, *Out-Doors at Idlewild* (New York: Charles Scribner, 1854), p. 130.

The novels of Cooper's last decade (with the significant exception, as we shall see, of *Wyandotté*) similarly testify to the tardy encouragement of landscape art. The special circumstances needed for its introduction were for a long time lacking. It was a matter of money, leisure, taste, and professional knowledge, which taken together might be utilized toward the improvement of gentlemen's estates; but these were advantages not conspicuous on the frontier or even in the more settled areas during the early years of the republic. When Corny Littlepage, the narrator of *Satanstoe*, visits the Mordaunt patent, Ravensnest, in the summer of 1758, to find the clearing in which the settlement has been established "disfigured by stumps, dead and girdled trees, charred stumps, log-heaps, brush, and all the other unseemly accompaniments of the first eight or ten years of the existence of a new settlement," he reflects that this is the period in the history of a country that "may be likened to the hobble-dehoy condition in ourselves, when we have lost the graces of childhood, without having attained the finished forms of men." When, following the war with England, Corny's son Mordaunt (Cooper's narrator in *The Chainbearer*), who has inherited the patent from his maternal grandfather, sees Ravensnest for the first time, the stumps have disappeared, but aside from the "improvements" brought about by time and decay, little progress is visible. "The thirty years of the settlement of my patent," remarks the heir, "had not done much for it, in the way of works of art." Sixty years later, Hugh Littlepage *(The Redskins)*, recently returned from the European grand tour, travels to Ravensnest to confront the anti-rent agitators who have put his inheritance in jeopardy. His description of the ancestral seat as it appears nearly a century after the granting of the patent suggests that the union of art and nature is still to be achieved. "Notwithstanding the cheapness of land among us," he declares,

there has been very little progress made in the art of
landscape gardening; and if we have anything like park
scenery, it is far more owing to the gifts of a bountiful
nature than to any of the suggestions of art. Thanks to the
cultivated taste of Downing, as well as to his well-directed
labors, this reproach is likely to be soon removed, and
country life will acquire this pleasure, among the many
others that are so peculiarly its own.

This is written from the vantage point of the 1840s, more than
two decades after Cooper undertook his improvements at
Scarsdale. In the interval, if we can trust Hugh Littlepage's
remarks, landscape art in this country has progressed not at
all. A century of development, during which the English gar-
den gained a dominant influence in Europe, seems, in Hugh's
view, to have produced no parallel phenomenon on this side
of the Atlantic. Certain it is, he observes, "that as a nation, we
have yet to acquire nearly all that belongs to the art that lies
beyond avenues of trees, with an occasional tuft of
shrubbery"—all, that is, that lies beyond the reach of art ex-
pressed in the design of Judge Temple's grounds in *The
Pioneers*. As opposed to the appreciation of landscape art in
Europe, Hugh continues, dropping into the language of the
landscape gardener, "the beauty of curved lines, and the
whole finesse of surprises, reliefs, backgrounds, and vistas, are
things so little known among us as to be almost 'arisdogratic,'
as my Uncle Ro would call the word. Little else had been done
at Ravensnest than to profit by the native growth of the trees,
and to take advantage of the favorable circumstances in the
formation of the grounds."

Hugh's observations may be overly pessimistic. Though
they echo Downing's remark in the same period that "with
regard to the literature and practice of Landscape Gardening as
an art, in North America, almost everything is yet before us,

comparatively little having yet been done,"[9] they tend to overlook Downing's claim, in the same chapter of his book, that "Landscape Gardening, in America, combined and working in harmony as it is with our fine scenery, is already beginning to give us results scarcely less beautiful than those produced by its finest efforts abroad."[10] This may argue merely that Downing the publicist is not entirely consistent with Downing the historian, but the fact seems to be that country gentlemen in the first half of the century—Cooper among them—planned their own improvements, with the guidance of individual taste and the manuals available from abroad, and that for most of them the only criteria were the choice of a naturally pleasing or unusual site and the laying out of straight avenues and gravel walks. This being so, the Cooper who around 1820 was engaged in digging a ha-ha to divide his lawn from his grounds and who a decade and a half later would design an English garden for his Cooperstown estate appears to be a man acquainted with landscape practices in England and, as such, well in advance of developments at home.

II

But if we accept the general account of the progress of the art in America offered by the narrators of the Littlepage trilogy, what are we to make of that singular though not very successful romance of Cooper's final decade, *Wyandotté, or The Hutted Knoll*, whose history of Captain Willoughby's improvements on his remote wilderness property in the years before the American Revolution seems so curiously—and to some readers, such as Poe, so gratuitously—anachronistic? The

[9] Downing, *A Treatise on the Theory and Practice of Landscape Gardening*, p. 40.
[10] Ibid., p. 19.

problem of *Wyandotté*, which is basically a structural one, is so challenging, and it is so clearly bound up with Cooper's indulgence of his gardening hobby, that it will preempt the remainder of this chapter.

Wyandotté begins with a brief essay on American scenery, or rather, the scenery of that settled portion of the continent east of the Mississippi that Cooper knew. (Had he been familiar with the Rockies or the great mountain ranges of the West Coast his remarks would have had to be modified.) "There is," he insists, "a widespread error on the subject of American scenery":

> From the size of the lakes, the length and breadth of the rivers, the vast solitudes of the forests, and the seemingly boundless expanse of the prairies, the world has come to attach to it an idea of grandeur; a word that is in nearly every sense misapplied. The scenery of that portion of the American continent which has fallen to the share of the Anglo-Saxon race very seldom rises to a scale that merits this term; when it does, it is more owing to the accessories, as in the case of the interminable woods, than to the natural face of the country. To him who is accustomed to the terrific sublimity of the Alps, the softened and yet wild grandeur of the Italian lakes, or to the nobler witchery of the shores of the Mediterranean, this country is apt to seem tame and uninteresting as a whole; though it certainly has exceptions that carry charms of this nature to the verge of loveliness.

Such, in fact, is the character of "that region which lies in the angle formed by the junction of the Mohawk with the Hudson," where the action of *Wyandotté* will occur. Cooper describes its typical landscape as "charming" rather than grand, praises its "capabilities," remarks on its lack of "high finish," and concludes that perhaps "the absence of pic-

turesque as connected with the works of man, is a general defect." A defect, we might add, that the pioneer family in *Wyandotté* will do its best to remedy.

Into this wilderness, in the spring of 1765, comes Captain Willoughby, a true-born Englishman retired from His Britannic Majesty's service, who has spent many years in the colonies, taken an American wife, fathered a son and daughter, and now, having secured a patent near the headwaters of the Susquehanna not far from the future site of Cooperstown, plans "to retire to his new possessions, in order to pass the close of his life in the tranquil pursuits of agriculture, and in the bosom of his family." Willoughby's Patent, as it comes to be known, is a tract of more than seven thousand acres, buried deep in the wilderness, accessible from Albany only by a journey of several weeks by inland waterways. The feature of the site that has attracted Captain Willoughby is a beaver pond, four hundred acres in extent, in the center of which, rising about forty feet from the surface of the water, is a rocky knoll of some five or six acres. On this island he raises his hut, the forerunner of the large fortified house he will subsequently build to accommodate his family and their domestics. Then he decides to drain the ancient pond by removing the beaver dam, in order by this device to have a farm largely cleared of trees and stumps. By the time Mrs. Willoughby, who has been biding her time in Albany, arrives with the household staff in the spring of the following year, it is evident that Captain Willoughby has decided to follow Pope's injunction to "consult the Genius of the Place in all"[11]—Virgil's *Genius loci* to which the English garden had long paid deference—by taking advantage of the site's natural features in the construction of his house and by respecting the

[11] Alexander Pope, "Epistle to Lord Burlington," *Moral Essays* IV: line 57.

natural lines of the forest perimeter. When Mrs. Willoughby, following the impulse of so many genteel but athletic Cooper females before her, climbs to a rocky point overlooking the drained pond, she is delighted by the prospect. The entire surface of the four hundred acres surrounding the Knoll is "smooth and fit for the plough." The form of the area, she notes, is "a little irregular; just enough so to be picturesque; while the inequalities were few and trifling." On the theory, again as expressed by Pope, that "He gains all points, who pleasingly confounds,/ Surprizes, varies, and conceals the Bounds,"[12] the picturesque improver had been at work:

> Trees had been felled around the whole area, with the open spaces filled by branches, in a way to form what is termed a brush fence. This is not a sightly object, and the captain had ordered the line to be drawn within the woods, so that the visible boundaries of the open land were the virgin forest itself. His men had protested against this, a fence, however unseemly, being in their view an indispensable accessory to civilization. But the captain's authority, if not his better taste, prevailed; and the boundary of felled trees and brush was completely concealed in the background of the woods.

In disguising his boundaries Captain Willoughby reflects the predilection of Cooper, who, in his essay for *The Home Book of the Picturesque* (1851), complained that rail fences were "objects which the lovers of the picturesque would gladly see supplanted by the brier and the thorn."[13]

At this point the narrative passes over a decade and resumes in May, 1775. The interval of peace is about to be ended by the events at Bunker Hill, Concord, and Lexington. The family circle at the Knoll is now complete; the economy of the

[12] Ibid.: lines 55–56.
[13] *The Home Book of the Picturesque, or, American Scenery, Art, and Literature* (New York: G. P. Putnam, 1851), p. 53.

plantation, supported by more than a hundred settlers, is self-sufficient; and the action proper, long delayed, is about to get under way with the appearance of the captain's son, Major Robert Willoughby, who will try to persuade his father to accept the baronetcy left vacant by the death of a cousin in England.

"To this sylvan scene," Cooper declares, "we must now bring the reader in fancy." The rich bottom lands of Willoughby's Patent are now a model of "agricultural finish," and the shrubbery, "of which the good captain's English taste had introduced quantities," is newly in leaf. "The site of the ancient pond was a miracle of rustic beauty. Everything like inequality or imperfection had disappeared, the whole presenting a broad and picturesquely shaped basin, with outlines fashioned principally by nature, an artist that rarely fails in effect." In dividing the fields by low post-and-rail fences, the captain has violated the rules of park improvement,[14] but in his disposition of the barns and outbuildings he has tried to preserve the integrity of the natural landscape. They are "neatly made and judiciously placed," so that from the wing of the house, built along a cliff, which the family occupies during the day, they are "removed from view." Moreover, the lanes that lead to them from the house "[cross] the low-land in such graceful curves, as greatly to increase the beauty of the landscape." Here and there a log cabin is visible, half hidden in the skirts of the forest in a manner calculated to secure that effect of "novelty" or "surprise" beloved of picturesque improvers, and the mills are "buried in the ravine, where they had been first placed, quite out of sight from the picture

[14] William Gilpin inveighs against palings, clipped hedges, in fact "all divisions of property" as "inimical to the picturesque." "It is *clipping* and *making*," he declares, "which ruin the picturesque idea. Utility is always counteracting beauty." *Remarks on Forest Scenery* (London: T. Cadell and W. Davies, 1808), II: 80.

above, concealing all the unavoidable and ungainly-looking objects of a saw-mill yard."

The same agricultural finish characterizes the Knoll. Its sloping southern exposure has been converted into a lawn (as distinct, in landscape gardening parlance, from the park, which extends from the base of the Knoll), "intersected with walks, and well garnished with shrubbery." What is "unusual in the America of that day," Cooper explains—and it is a significant admission—is that the captain, "owing to his English education, had avoided straight lines and formal paths; giving to the little spot the improvement on nature which is a consequence of embellishing her works without destroying them." Some of the embellishments have been entrusted to Beulah Willoughby, the captain's daughter, to whom "her parents had yielded control of everything that was considered accessory to the mere charms of the eye." Beulah has carried out her mandate by tamping earth into the fissures of the rocks on the abrupt northern face of the Knoll and planting wild roses. She may be responsible, too, for the "rude and sufficiently picturesque garden-seats" that are disposed about the lawn and at intervals along the winding forest paths that overlook the basin.

In this attempted fusion of beauty with utility what we have, in embryo at least, is the *ferme ornée* of mid-eighteenth-century England, the best known example of which was William Shenstone's Leasowes. In the most general sense, Captain Willoughby's aim has been that of Shenstone, to unite farm and park, an impractical venture if carried out to the degree that the poet-farmer did at Leasowes but successful within the more modest scope of Captain Willoughby's design. In spite of the strategically placed rustic seats, the winding walks in the vicinity of the Knoll are not, so far as we are told, laid out like those at Leasowes to lead the stroller from one designated vantage point to another, at each of which he

may contemplate a carefully framed and composed pastoral landscape. Nevertheless, Captain Willoughby's guiding principle, like that of Shenstone and other eighteenth-century improvers, has been to disguise the practical signs of husbandry by the devices of the landscape gardener. The basin surrounding the Knoll is first of all a pastoral retreat and only by casual definition a working farm or practical settlement. The only building distinctly visible from the Knoll is the church, located with a view to picturesque effect on a low swell in the center of the meadow. What Captain Willoughby's estate lacks, of course, are ruins and other hallowed artificial accessories, together with the associations they inspire.

It is impossible at this distance to determine to what school, if any, Cooper went for his views on landscape gardening. He was, in Natty Bumppo's term, a "younker" when the controversy between those uneasy allies Richard Payne Knight and Uvedale Price on the one side and Humphry Repton on the other was at its height. What literature on the subject he read, what principles he followed when he made his first experiments at Scarsdale, probably cannot be known. Though he speaks favorably of Downing and his influence, there is no evidence that they ever met. In this matter, as in that of his fictional theory, his journals and letters are of almost no help. His travel books, on the other hand, at least indicate a lively interest in the subject of landscaping, as well as certain firm convictions, admittedly widespread even before his day, in favor of the English garden. The formal gardens of the French such as those designed by Le Notre for Versailles, had in the eighteenth century come to symbolize autocracy and the dominance of man over nature, as opposed to the English irregular gardens, which symbolized "constitutionalism and man's alliance with nature."[15] For this reason, both Rousseau

[15] H. F. Clark, *The English Landscape Garden* (London: Pleiades Books, 1948), p. 10.

and Montesquieu had favored the English garden, and the same democratic bias may have been at the back of Cooper's mind when he was confronted by the formal garden. Travelling up the Seine, he remarks a country seat along the banks "in the ancient French style, with avenues cut in formal lanes, mutilated statues, precise and treeless terraces, and other elaborated monstrosities," and comments that "considered in reference to what is desirable in landscape gardening, these places are the very *laid idéal* of deformity."[16] His preference, like that of the English school in general, is for preserving the natural features of the landscape. What he demands from a view are the elements that have been stressed since Pope, the common denominators of all schools and parties, whatever their disagreements: simplicity, variety, contrast, novelty (or surprise), and concealment. All of these qualities except the last are inherent to a degree in the natural landscape, though they may be enhanced by the skill and judgment of the landscaper. In the following passage, for example, Cooper, en route from Rouen to Paris, is viewing a cultivated landscape, yet his description stresses the value, successively, of novelty, concealment, and contrast (light and shade):

> The appearance of the country was extraordinary in our eyes. Isolated houses were rare, but villages dotted the whole expanse. No obtrusive colours, but the eye had frequently to search against the hill-side, or in the valley, and, first detecting a mass, it gradually took in the picturesque angles, roofs, towers, and walls of the little *bourg*. Not a fence, or visible boundary of any sort, to mark the limit of possessions. Not a hoof in the fields grazing, and occasionally, a sweep of mountain land resembled a pattern card, with its stripes of green and yellow and other hues, the narrow fields of the small proprietors. The play of light and shade on these gay upland patches, though not strictly

¹⁶ Cooper, *Gleanings in Europe: France:* 73.

in conformity with the laws of taste, certainly was attractive.[17]

Where man has made the landscape submit to his necessities, the improver must try to unite art with nature. Of a view near the village of Tron, Switzerland, Cooper writes almost as if describing the setting of *Wyandotté*: "All the artificial parts of this view were in admirable harmony with its natural character; the cottages being grave and picturesque, the fences light and graceful, and the roads merely bridle paths."[18]

Like the William Kent of Walpole's famous phrase, Cooper has leaped the fence and found all nature to be a garden, so that his fictional treatment even of uncultivated nature will be informed by the landscape gardener's, as well as the landscape painter's, vision. They are, in fact, inseparable visions ("The landscape painter," as William Shenstone expressed what would become a truism in the next generation, "is the gardener's best designer")[19] and combine to form the picturesque vision.

Captain Willoughby, it may be noted, does not carry his improvements very far in the direction of the picturesque. The term as applied to landscape gardening had as yet no currency in the England, much less the America of 1765, and though Cooper employed it freely in *Wyandotté*, he was sufficiently aware of the anachronism it involved to banish it from the vocabulary of his characters. The writings of the picturesque school, mainly those of Gilpin, Knight, and Price, were yet to appear;[20] consequently, the embellishments at the Knoll are modest enough and do not transgress the principles that

[17] Cooper, *Gleanings in Europe: France:* p. 82.

[18] Cooper, *Sketches of Switzerland*, II: 85.

[19] Quoted in H. F. Clark, *The English Landscape Garden*, p. 25.

[20] The term "picturesque beauty" was originally defined in Gilpin's, *The Essay on Prints* (1768) as "that particular kind of beauty, which is agreeable in a picture."

would have governed the improvements of a William Kent or
a Capability Brown. The most thorough and imaginative use
of landscaping techniques in mid-century England were those
employed by Henry Hoare at Stourhead, whose grounds, by
1765—the year Captain Willoughby begins his improve-
ments—presented, in Horace Walpole's judgment, "one of the
most picturesque scenes in the world."[21] But the adjective as
Walpole customarily employed it had very different and less
specific connotations from those it would have had for the
repatriated Cooper, and the more accurate term for the
landscape at Stourhead, consciously designed after paintings
by Claude to satisfy an ideal of harmony and order, would
have been "beautiful." Captain Willoughby's improvements
do not, at any rate, anticipate the more extreme picturesque
development sponsored by Uvedale Price, J. C. Loudon, and,
in America, Andrew Jackson Downing. The captain does not
try to accentuate the bolder existing features of his site; in fact,
he removes "everything like a visible rock, the face of the cliff
on the northern end of the Knoll excepted" and utilizes the
rocks for walls, while his daughter Beulah, it will be recalled,
does her bit to soften the rugged contours so beloved of the
later picturesque school by planting wild roses in the crannies
of the rock face. Beulah could in fact be following the more
conservative advice of William Gilpin, whose influence was in
the ascendant in England at that very moment, for he disap-
proved of "the rock, bleak, naked, and unadorned" as an or-
nament of landscape: "Tint it with mosses, and lychens of
various hues, and you give it a degree of beauty. Adorn it with
shrubs and hanging herbage, and you still make it more pic-
turesque."[22] At any rate, the landscape of the Knoll has, in
Walpole's cautionary terms, been "chastened or polished, not

[21] Quoted in Edward Malins, *English Landscaping and Literature,
1660–1840* (London: Oxford Univ. Press, 1966), p. 49.

[22] *Observations on the River Wye*, pp. 23–24.

transformed,"[23] and the distinction is significant.

Had Captain Willoughby survived into another generation to follow the Knight–Price–Repton controversy as to whether utility or picturesque effect should be the landscape gardener's primary concern, he probably would have sided with Repton, who complained that "the modern rage for natural landscape has frequently carried its admirers beyond the true limits of improvement, the first object of which ought to be convenience, and the next picturesque beauty."[24] And if I may pursue this paradoxical gambit to its conclusion, it is reasonable to deduce from the nature of Captain Willoughby's improvements that he would have agreed with Repton's doctrine, in Chapter VI of his *Sketches and Hints on Landscape Gardening* (1795), that "the perfection of landscape gardening consists in the four following requisites":

> First, it must display the natural beauties and hide the natural defects of every situation. Secondly, it should give the appearance of extent and freedom, by carefully disguising or hiding the boundary. Thirdly, it must studiously conceal every interference of art, however expensive, by which the scenery is improved, making the whole appear the production of nature only; and, fourthly, all objects of mere convenience or comfort, if incapable of being made ornamental, or of becoming proper parts of the general scenery, must be removed or concealed.[25]

Like Repton, Captain Willoughby has a regard for utility not always sanctioned by the picturesque extremists, but he also insists, as did Repton, that its operations be so far as possible concealed.

[23] Horace Walpole, "The History of the Modern Taste in Gardening," reprinted in Isabel Wakelin Urban Chase, *Horace Walpole: Gardenist* (Princeton: Princeton Univ. Press for Univ. of Cincinnati, 1943), p. 27.

[24] John Nolen, ed., *The Art of Landscape Gardening* (Boston: Houghton Mifflin, 1907), p. 163.

[25] Ibid., p. 43.

III

Susan Cooper, writing in *Pages and Pictures* of the composition of *Wyandotté*, remarks that her father "was most thoroughly a pioneer in spirit." In this sense Cooper's kinship with Captain Willoughby is inescapable. "He delighted," continues his daughter, "in the peculiarly American process of 'clearing'":

> Not in its ruder forms, of course, where the chief object of the colonist often appears to consist in felling a noble wood, and leaving the unsightly wreck—a lifeless array of half-charred stumps—to moulder slowly away, under the storm and sunshine of half a life-time. It was the work of improvement, in all its different stages, in which he took pleasure, from the first opening of the soil to the sunlight, through all the long course of removing the wood, burning the brush, the first tilling, and the first crop.[26]

It is this "clearing" stage, the first of the three stages in the progress of society in a new country as Cooper described them in the important twelfth chapter of *Home as Found*, that triggers Cooper's nostalgia for both the personal and national past and provides the rationale for those doomed utopias in *Wyandotté* and *The Crater*. "There is," he wrote in *Wyandotté*, "a pleasure in diving into a virgin forest and commencing the labors of civilization, that has no exact parallel in any other human occupation"—a pleasure, he adds, similar in kind but greater in intensity to "that of building, or of laying out grounds." This first stage is, in Cooper's own phrase, "the pastoral age," and it is characterized, in the true pastoral faith, by "the sort of kind feeling and mutual interest which men are apt to manifest towards each other when they are embarked in an enterprise of common hazards."

[26] S. F. Cooper, *Pages and Pictures*, p. 347.

In this "clearing" stage, a certain social levelling is inevitable. The gentleman is forced by circumstance to make common cause with those whose "education, habits, and manners" are inferior to his own; in this rough democracy the settlers mingle on "a sort of neutral ground," break bread as well as soil together, and experience the good fellowship and familiarity that Cooper, we gather, enjoys so long as he is confident that it is temporary, so long as he can be sure that "the claims of mere animal force" will yield eventually to "those of the higher qualities." This period, evoked so beautifully in *The Pioneers* and, as Cooper noted in *Home as Found*, "already passing into tradition," is "the happiest of the first century of a settlement." Its significance in the development of Cooper's social philosophy is plain: "It is found that they who have passed through this probation, usually look back to it with regret, and are fond of dwelling on the rude scenes and ridiculous events that distinguish the history of a new settlement, as the hunter is known to pine for the forest."

The second stage is that "in which society begins to marshall itself, and the ordinary passions have sway." Its symptoms are the struggle for money, power, and position, the growth of mutual distrust and antagonism between classes, and the descent into a kind of anarchy of taste and manners. It is "perhaps the least inviting condition of society that belongs to any country that can claim to be free, and removed from barbarism." It is the condition, in fact, in which Cooper, following his return from Europe, lived for the remainder of his life, the state of society delineated in *Home as Found* ("Templeton," he observes in that novel, "was properly in this equivocal condition"), *The Redskins*, and in the later chapters of *The Crater*. Cooper was not to live to see, or at least acknowledge, the advent of the third stage, when society submits to "the control of more general and regular laws," achieves a uniform civilization, and divides into castes "that

are more or less rigidly maintained, according to cir-
cumstances." We can see him, then, as living uneasily between
two worlds, one dead, the other powerless to be born. The
world of his boyhood, the pastoral age, buoyant, rude, and
necessarily transient, still exists, but on the margin of a fron-
tier with which he is only remotely familiar; and, looking
about him, he finds little evidence of the society he advocated,
firmly rooted in a regard for the gradations of class, education,
taste, and manners—a society that he tried for nearly three
decades to force into existence, reasonably at first and then
with increasing hauteur and an irritability bordering on can-
tankerousness.

To turn for a moment to the structure of *Wyandotté*,
which, like that of so many of Cooper's romances, appears to
be indefensibly haphazard: Poe, in his review of the work,
reported that "nearly the whole of the first volume is occupied
with a detailed account of the estate . . . and of the progressive
arrangements and improvements."[27] He is of course ex-
aggerating; the account of the early settlement and subsequent
improvements occupies the first three chapters and part of the
fourth. But as a persistent advocate of unity of effect, Poe
would understandably be impatient with elaborate prepara-
tion which, in terms of theme and action, seems to lead
nowhere. His presumable expectation that the theme will
somehow accommodate the captain's passion for landscape
improvements or that the action will somehow justify that
passion is not fulfilled. The interest of the novel, in Poe's view
at least, depends on its primary theme, which he defined as the
universally appealing one of "life in the wilderness," but as is
usual in Cooper, he complains, that interest "has no reference
to plot." The tale is "a mere succession of events, scarcely any
one of which has any necessary dependence upon any other."

[27] Stedman and Woodbury, *The Works of Edgar Allan Poe*, II: 6–7.

Viewing *Wyandotté* solely in this light, Poe is justified in his strictures; the adaptation of means to ends is even more carelessly managed than usual in Cooper. But a rationale for the early chapters can be established to some degree with reference to the larger context of Cooper's writings. It hardly bears repeating by now that Cooper's settings are always fully and meticulously ·described, that he wants to make us so thoroughly familiar with the objects in the scene, their relative disposition and the distances between them, that like his forest characters we can, as it were, find our way about on the blackest night. But this does not explain the particular emphasis on setting in *Wyandotté*, which is determined by the unusual character of Captain Willoughby's venture and the nature of his improvements, and is understandable perhaps only in terms of Cooper's attempt to mediate between irreconcilable visions of the good life.

Returning for the moment to the aesthetics of landscape and to Cooper's European impressions, we are reminded that the traveller's enthusiasm, though intermittently aroused by the sublime or the beautiful, was more consistently evoked by the picturesque—by the particular character of the Swiss lakes, valleys, and bourgs—more frequently than by the sublimity of the Alps or by the beautiful but tame rural landscapes of England. Eden, if it exists, is not the wilderness (which in any case has its proper serpents, whether they be treacherous Indians or renegade whites), but in a nature partially subdued, retaining something of its wildness but shaped to man's simpler and, by implication, more virtuous necessities; for the beau ideal of civilized character in Cooper's fiction is that in which a basic "simplicity and nature" (to cite a recurrent phrase) have engaged on equal terms the influence of "refinement and good breeding." The precarious Eden that Captain Willoughby has carved out of the wilderness is a compromise between nature and civilization. Regarded simply as

landscape, it finds its character somewhere between the sub-
lime, which is the creation of nature and may be represented in
this instance by the interminable forest that surrounds the
Knoll, and the beautiful, which in its purest manifestation is
the product of civilization and art.

This is more, I am convinced, than a manner of speaking or
a juggling of concepts to provide an analogy for Cooper's
social and aesthetic prepossessions. The aesthetic scheme
developed by Uvedale Price and his followers, which located
the picturesque midway between the sublime and the
beautiful (by combining, in Price's terms, the opposite
qualities of smoothness and roughness, gradual variation and
sudden variation, and, by extension, the ideas of youth and
age) was, as has been noted, integral to Cooper's mode of
perception. It is therefore not inconceivable that it could have
figured in the genesis of *Wyandotté* by enabling Cooper to
define the essential nature and significance of Captain
Willoughby's experiment. The captain has planted an English
garden in the heart of the wilderness. "The neatness, simplici-
ty, and elegance of English gardening," wrote Humphry Rep-
ton at the end of the eighteenth century, "have acquired the
approbation of the present century, as the happy medium
betwixt the wildness of nature and the stiffness of art; in the
same manner as the English constitution is the happy medium
betwixt the liberty of savages, and the restraint of despotic
government."[28]

Cooper's imagination in his later years, seeking refuge from
the gross realities of the present, finds it in the realms of
memory or hope, in the recreation of a pastoral age or in a vi-
sion, however transient, of utopia. In *Wyandotté*, as in the
Littlepage trilogy and *The Crater*, Eden must sink to grief; but
for a moment in time Captain Willoughby has combined the

[28] Letter to Uvedale Price, in Price, *Essays on the Picturesque*, III: 10.

happiest features of the first and third stages in the progress of a new society—the rough but genial democracy of the infant settlement with the benevolent patriarchy whose prototype Cooper had admired when he visited his friend Lafayette at La Grange. Until the outbreak of the revolution the heterogeneous population of the Knoll is content to be governed by the imperatives of law, the caste structure, and that view of civilization that includes in its rationale the improvement of the landscape—the contribution of art to nature. For Cooper, both the planting and the improvement stages were "pregnant with anticipations and hopes." The labor they entailed, the sense of creativity they involved, were inseparable from the cultivators' hopes for the future. In *Wyandotté* the present, equated in Cooper's mind with the influence of money and the contest for power and status, and stridently embodied in the Cooperstown to which he returned in 1833, is denied its place in the picture. By draining the beaver pond and thus avoiding the prolonged labor of clearing the land for agriculture, Captain Willoughby has in effect advanced the time-table and eliminated the second stage, the "transition" stage with its attendant social evils. The Knoll has in a miraculously short interval passed from wilderness into civilization.

But as in *The Crater*, the pastoral idyll is short-lived. Cooper's attempt to conjoin natural and artificial society—so curious a modification of his account in *Home as Found* of the first stage of society or his depiction of it in the Littlepage trilogy—proves to be a forced graft. With the advent of war, this ideal cooperative society is destroyed by forces from without conspiring with forces from within. As always in Cooper, hard upon the heels of the Natty Bumppos, Chainbearers, and Captain Willoughbys come the exploiters, the Ishmael Bushes, Jason Newcomes, and Joel Strideses—those Snopses of the early republic, vicious, predatory, and fecund as rabbits—who inaugurate the second stage of

social development which Captain Willoughby's experiment, it now appears, has not bypassed but only delayed. There is, it might be argued, a double time scheme at work in *Wyandotté*,—one on the level of wish fulfillment, the other on the level of reality,—and Cooper's vision cannot accommodate both without impairing the logic and unity of his action. Hence the failure, of which Poe was so cognizant, of either of the two disproportionate segments of his plot to implicate the other. It is a failure that Cooper would not repeat in *The Crater.*

4

Schema and Picture

I

What Cooper as a visual artist learned from his travels on the continent is apparent in the later romances. His sharpened awareness of the pictorial values to be sought in the natural landscape and of the means by which these values could be introduced into imagined landscape is most evident in such works as *The Pathfinder*, *The Deerslayer*, *Wyandotté*, *The Oak Openings*, and the Littlepage trilogy—in other words, in the forest romances written after his return. The opening chapters of the last two Leatherstocking tales, for example, are unforgettable simply as pictures, and both depend for their effect on a motif that Cooper exploited most vividly in his later works: the natural clearing, such as glade, windrow, or oak opening, whose value was both pictorial and psychological—pictorial by virtue of the heightened contrasts between light and shade, open space and interminable forest, and by virtue also of the frame it provided within which the elements of the picture could be composed and the action of the story arrested for a moment; psychological because it provided an exhilarating relief from the claustrophobic experience of the woods.

The first example is from the opening chapter of *The Pathfinder*:

The particular wind-row of which we are writing lay on the brow of a gentle acclivity, and it opened the way to an extensive view to those who might occupy its upper margin, a rare occurrence for the traveller in the woods. . . . On the upper margin of the opening . . . the viewless influence had piled tree on tree, in such a manner as had not only enabled the two males of the party to ascend to an elevation of some thirty feet above the level of the earth, but, with a little care and encouragement, to induce their more timid companions to accompany them. The vast trunks that had been broken and driven by the force of the gust, lay blended like jackstraws. . . . One tree had been completely uprooted; and its lower end, filled with earth, had been cast uppermost, in a way to supply a sort of staging for the four adventurers.

The scene, with its pile of storm-blasted and fallen trees in the foreground and the forest prospect stretching away to the horizon, testifies to Cooper's power to enlist the sublime when the occasion warranted in order to emphasize the dignity and grandeur of the American wilderness. Dead or fallen trees speak eloquently to the imagination, as in the landscapes of Salvator Rosa; they record, as William Gilpin observed, "the history of some storm, some blast of lightning, or other great event, which transfers its grand ideas to the landscape, and in the representation of elevated subjects assists the sublime."[1] Here is one instance, moreover, in which Cooper has been able to unite the prospect view with a striking foreground emphasis to achieve a landscape that a painter might reproduce.

The second example is from the magnificent opening chapter of *The Deerslayer*. Following the general description of the forest, we hear human voices calling from its depths and at length a shout proclaiming success,

[1] Gilpin, *Remarks on Forest Scenery*, I: 9.

. . . and presently a man of gigantic mould broke out of the tangled labyrinth of a small swamp, emerging into an opening that appeared to have been formed partly by the ravages of the wind, and partly by those of fire. This little area, which afforded a good view of the sky, although it was pretty well filled with dead trees, lay on the side of one of the high hills, or low mountains, into which nearly the whole surface of the adjacent country was broken.

An example of what Cooper calls those "oases in the solemn obscurity of the virgin forests of America," the clearing provides a natural site for the reunion of Hurry Harry March and Deerslayer, who have become separated in their journey toward Glimmerglass; but the effect is theatrical, as if the curtain has gone up on an empty stage and a moment later the principal actors emerge from the wings. Reunited, the two woodsmen plunge again into the forest and minutes later emerge on the shore of the lake. At this point Cooper has the opportunity to describe in both general and precise terms the setting which will accommodate all of the subsequent action, the fabled Glimmerglass, with its surface "so placid and limpid that it resembled a bed of the pure mountain atmosphere, compressed into a setting of hills and woods." This description, like many that occur later in the narrative, emphasizes the influence of picturesque theory on Cooper's visual imagination.

The general outline of the lake, which is about three leagues in length, meets the requirements of the picturesque; its margin is irregular, "being dented by bays and broken by many projecting points," and its banks are festooned with bushes and small overhanging trees. "The effect," writes Cooper, donning his landscape gardener's hat, "was precisely that at which the lover of the picturesque would have aimed, had the ordering of this glorious setting of forest been submitted to his control. The points and bays, too, were sufficient-

ly numerous to render the outline broken and diversified." A quarter of a mile offshore stands Muskrat Castle, built on piles driven into a long narrow shoal submerged at a depth of six to eight feet below the surface. This is Tom Hutter's fortified dwelling, where he lives with his daughters, Hetty and Judith, and it is the central magnet around which, as with the standing rock in *The Prairie* and the fortified mound in *The Wept of Wish-ton-Wish*, the choreography of flight, capture, escape, and pursuit will be designed. Although the name "Muskrat Castle" is the facetious inspiration of a British officer, it lends itself to what I am persuaded is a serious strategy on Cooper's part. In one of many passages in his writings, similar in tone and burden, where he is citing the superiority of the old world over the new in the matter of picturesque features, his example is fortified structures:

> The necessity, in the middle ages, of building for defence, and the want of artillery before the invention of gunpowder, contributed to the construction of military works for the protection of the towns of Europe, that still remain, owing to their durable materials, often producing some of the finest effects that the imagination could invent to embellish a picture. Nothing of the sort, of course, is to be met with here, for we have no castles, have never felt the necessity of fortified towns, and had no existence at the period when works of this nature came within the ordinary appliances of society. . . . It is not to be denied that so far as the landscape is concerned, the customs of the middle ages constructed much the most picturesque and striking collections of human habitations.[2]

With this emphasis in view, it seems clear that Cooper designed Muskrat Castle not simply as the central motif in a picturesque landscape but as a structure which might borrow its

[2] *The Home Book of the Picturesque*, p. 66.

associations from the European past and, with the lapse of time, acquire an associational value of its own. Three separate passages encourage this inference. "As he approached the building of old Hutter," Cooper writes,

> Deerslayer thought, or rather *felt*, that its appearance was in singular harmony with all the rest of the scene. Although nothing had been consulted but strength and security, the rude, massive logs, covered with their rough bark, the projecting roof, and the form, would contribute to render the building picturesque in almost any situation, while its actual position added novelty and piquancy to its other points of interest.

Later in the narrative Tom Hutter and Hurry Harry are on board the Ark, at a distance from the Castle, as the dawn unfolds over Glimmerglass:

> Only one solitary object became visible in the returning light, that had received its form or uses from human taste or human desires, which as often deform as beautify a landscape. This was the castle; all the rest being native, and fresh from the hand of God. That singular residence, too, was in keeping with the natural objects of the view, starting out from the gloom, quaint, picturesque, and ornamental.

All the elements of the picturesque are present in these passages: the emphasis on roughness as opposed to smoothness, on the singularity (novelty) of the structure, on the contrast of the human artifact with the natural setting and, at the same time, its harmony with that setting. Fifteen years after the events of the romance are concluded, Deerslayer and Chingachgook return to the shores of Glimmerglass. "From the point," Cooper writes, "the canoe took its way toward the shoal, where the remains of the castle were still visible, a picturesque ruin." Time has done its work, and the epilogue evokes the same pleasing melancholy that the picturesque

traveller derives from his experience of the more ancient and
legitimate ruins of Europe. (It is an effect Cooper will repeat in
the epilogue of *Wyandotté*.) The events on Glimmerglass, ex-
citing certainly, but of a deeper human significance than is
usual in Cooper, have in retrospect conferred on the setting an
associative value that, in kind if not in intensity is likewise
present in Thomas Cole's Volney-like meditations on the ruin
of empire when, seated on a fallen column at dusk in the
Roman Campagna, he conceives his series of heroic canvases,
The Course of Empire, and summons for his companions "a
picture that found its parallel in the melancholy desolation by
which, at that moment, they were surrounded."[3] Cooper had
experienced his own vision on the identical site. His descrip-
tion of the Campagna in his Italian *Gleanings* not only echoes
the thought and tone of Cole's meditation but reproduces with
astonishing fidelity the scene as it appears in the painter's 1843
landscape of the Roman Campagna in the Wadsworth
Atheneum:

> But that plain! Far and near it was a waste, treeless, almost
> shrubless, and with few buildings besides ruins. Long
> broken lines of arches, the remains of aqueducts, were visi-
> ble in the distance; and here and there a tower rendered the
> solitude more eloquent, by irresistibly provoking a com-
> parison between the days when they were built and
> tenanted, and the present hour.[4]

Another detail in Cooper's *Deerslayer* setting reinforces the
impression that he is trying to fabricate, out of whatever
materials lie at hand, associations which by attaching his
American readers' imaginations to a particular place will
enhance their attachment to the country as a whole, and also
that, like Scott before him, he has more than one strategem for

[3] Noble, *The Course of Empire*, p. 155.
[4] Cooper, *Gleanings in Europe: Italy*, II: 60.

achieving this end. After Muskrat Castle, the most con-
spicuous feature in Cooper's survey of Glimmerglass is the so-
called "rendezvous rock," shaped like a beehive or haycock
and rising from the surface near the outlet of the lake at a
short distance from the shore. Cooper as usual is scrupulous
in fixing its appearance and location because, like the Castle, it
provides a focal point for several incidents in the narrative.
But unlike the Castle, the rock is an actual feature of Lake
Otsego still to be seen at the northern end of the lake, standing
about fifty feet from shore in water two feet deep. Like Glenns
Falls in *The Last of the Mohicans*, or the "solitary and silent
spring" in the same work, around which, as the reader is in-
formed, will some day rise a fashionable spa, or the "Newport
Ruin" of mysterious origin in *The Red Rover*, the rendezvous
rock, in furnishing a real setting for imagined events, is
translated into that realm where history and fiction become
one and the "associations" which originate in the romancer's
imagination survive as vividly as those established by actual
history. It is only, one is tempted to claim, a matter of scale:
what Scott in *The Heart of Midlothian* does for Arthur's Seat,
Cooper does for a rock of more modest dimensions in his
native lake. The device is so familiar as to be hardly worth
noting except that Cooper, as we have seen, began his career at
the moment when the question of what associations the
American novelist might legitimately exploit was being aired
most extensively. Cooper's forests and his strongholds,
natural and man-made, his prehistoric mounds and Newport
Ruins, his uprooted giants of the forest and beehive-shaped
rendezvous rocks, which serve both the landscape artist and
the romancer as picturesque elements and as sources of
association, may be invoked to counter Cooper's lifelong com-
plaint (as expressed in his 1850 preface to *The Red Rover*) that
"the history of this country has very little to aid the writer of
fiction, whether the scene be laid on the land or on the water."

In his last forest romance, *The Oak Openings* (1848),
Cooper placed his action in the West beyond the frontier, as
he had in *The Prairie*, in the "then unpeopled forest of
Michigan," a region he had visited, though many years after
1812, when the events of the tale occur. "The American
forest," he wrote, "has so often been described as to cause one
to hesitate about reviving scenes that may possibly pall, and in
retouching pictures that have been so frequently painted as to
be familiar to every mind," but he promises that if the reader
will bear with him he may discover in "the virgin forests of
this widespread land . . . new subjects of admiration." This is
not the wilderness of upper New York state; though wild,
Michigan "[offers] a picture that [is] not without some of the
strongest and most pleasing features of civilization." It is low
and rolling country, and consequently lacking in those
features readily available for picturesque representation, the
mountain lakes and craggy rocks as well as the memorials of
earlier habitation, the ruined forts and artificial mounds; and
although wooded, "it [is] not as the American forest is wont to
grow, with tall, straight trees towering towards the light, but
with intervals between the low oaks that [are] scattered
profusely over the view, and with much of that air of
negligence that one is apt to see in grounds where art is made
to assume the character of nature." In other words, the
scenery is more park-like than wild, and this perception will
govern Cooper's treatment of one of the central locales of the
action, the Prairie Round, where the bee-hunter, Ben Boden,
displays his skill to the Indians. The description of this "oak
opening," it will be readily apparent, not only draws upon the
vocabulary of the landscape gardener but presents a landscape
which in its almost clipped and formal aspects would appeal
more to the taste of a Capability Brown or Humphry Repton
than to that of a Gilpin or Uvedale Price:

This well-known area is of no great extent, possessing a surface about equal to that of one of the larger parks of Europe. Its name was derived from its form, which, without being absolutely regular, had so near an approach to a circle as to justify the use of this appelation. The face of this charming field was neither waving, nor what is called "rolling," nor a dead flat, as often occurs with river bottoms. It had just enough of undulation to prevent too much moisture, and to impart an agreeable variety to its plain. As a whole, it was clear of the forest; quite as much as if the axe had done its work there a thousand years before, though wood was not wanting. On the contrary, enough of the last was to be seen, in addition to that which formed the frame of this charming landscape, to relieve the view from all appearance of monotony, and to break it up into copses, thickets, trees in small clusters, and in most of the varieties that embellish local scenery. One who had been unexpectedly transferred to the spot might well have imagined that he was looking on the site of some old and long-established settlement, from which every appliance of human industry had been suddenly and simultaneously abstracted. Of houses, outbuildings, fences, stacks, and husbandry, there were no signs; unless the even and verdant sward, that was spread like a vast carpet, sprinkled with flowers, could have been deemed a sign of the last. There were the glades, vistas, irregular lawns, and woods, shaped with the pleasing outlines of the free hand of nature, as if consummate art had been endeavoring to imitate our great mistress in one of her most graceful moods.

Visually the scene lacks the high degree of definition we expect from Cooper, but this is mainly because he has relied too casually on a convention that will enable him to introduce his reader to an unfamiliar type of native landscape. The general analogy with the eighteenth-century English park, expressed in language associated with the depiction of nature in that cen-

tury (the verdant swards sprinkled with flowers), hampers
Cooper's intention as much as it assists it; he is more redun-
dant than usual and to less effect.

The oak openings, of which Prairie Round is simply the
most remarkable example, are another variety of those
clearings that Cooper found so useful as a stage on which to
mount many of his opening scenes. The theatrical metaphor
that is only suggested in the opening scene of *The Deerslayer*
is explicit in the parallel scene of *The Oak Openings*. One is
aware from the beginning of Cooper's career of the theatrical
quality of many of his episodes, a quality that lent itself so
handily to the contemporary illustrator's emphasis on the
foreground action—the scenes of death, partings, reunions,
combat. But now, almost as if he were visualizing his episodes
in terms of the early nineteenth-century American stage with
its frequently elaborate scenic effects, Cooper drops easily into
the theatrical analogy. The year is 1812, he tells us in the first
chapter, the month July: "The sun was already approaching
the western limits of a wooded view, when the actors in its [his
legend's] opening scene must appear on a stage that is more
worthy of a particular description."

The stage is one of the openings, and, as in the first chapter
of *The Deerslayer*, the principal actors, nameless at first, are
brought together in this open glade. Similarly, when in
Chapter XVI Ben Boden and Corporal Flint make their noctur-
nal foray to spy on an Indian council, Cooper sets the stage
with great care for the impressive and self-contained drama,
complete with colorful dress, precisely timed entrances and ex-
its among the characters, and oratorical set-pieces—a pageant
by firelight enacted in a setting deliberately suggestive of the
theater. "It [the council fire] was in the precise center of a bit
of bottom land of about half an acre in extent, which was so
formed and surrounded as to have something of the
appearance of the arena of a large amphitheatre. There was

one break in the encircling rise of ground, it is true, and that was at a spot directly opposite the station of Le Bourdon and his companion, where the rill which flowed from the spring found a passage out toward more open ground."[5] In other words, if we regard Le Bourdon (Ben Boden) and the corporal as occupying the vantage point of the audience in a theater, the single break in the amphitheater wall is at the rear center stage, and, appropriately, it is through this entrance that two of the principal actors in the drama, Scalping Peter and Parson Amen, make their appearance. How literally Cooper pursued the theatrical analogy is evident from the fact that, having concluded his "brief description of the natural accessories of this remarkable scene," he adds: "But it was from the human actors, and their aspects, occupations, movements, dress, and appearance generally, that the awe which came over both the bee-hunter and the corporal had its origin." As Henry and Margaret Ogden have noted, both Salvator Rosa and Gaspar Dughet (Poussin) often used landscape to evoke a mood "tense and somewhat theatrical in quality": "Their aim was to create a mood similar to that of the climactic moment in a stage play, and this purpose dominated their choice of figures and setting."[6] It is an effect that Hawthorne in "Ethan Brand," employing the same elements including the amphitheater and the vivid contrast between firelight (the kiln) and the surrounding darkness, can bring off without the stage manager commentary; and to recognize the difference between the two treatments is simply to emphasize Hawthorne's awareness in most of his fiction of the need, for the purposes of psy-

[5] The amphitheatral form provides the principle for a separate and recurrent type of ideal landscape, developed by Claude and his followers; and it can be assumed that Cooper, familiar with the tradition, is making use of the motif, not only in *The Oak Openings* but in such other works as *The Wept*, *Wyandotté*, and *The Crater*.

[6] Henry V. S. and Margaret Ogden, *English Taste in Landscape in the Seventeenth Century* (Ann Arbor: Univ. of Michigan Press, 1955), p. 148.

chological drama, to exploit the possibilities of the close cir-
cumscription of space and of the conflict, mainly domestic, of
individual wills and purposes. In *The Oak Openings* the
drama is not psychological, except in the crudest terms; it
moves in an opposite direction, towards melodrama,
emphasizing pageant and decor. But in any case, the pictorial
impulse, as in Hawthorne, is strongly and self-consciously ac-
tive, and if Cooper, with his surveyor's passion for
topographical accuracy, is in some respects the clumsier and
less economical artist, he is, by the logic of his aims and
materials, the more ambitious. Except in works like *The
Pioneers* and *Wyandotté*, and of course the so-called social
novels, his landscapes, like the human actions with which
they are associated, are by necessity greater in magnitude than
Hawthorne's and more heroic than domestic.

Aside from the theatrical analogy, which Cooper could
have derived as well from the theater as from the Italian tradi-
tion of landscape painting, the examples of landscape tech-
nique I have cited from the later forest romances seem to me to
argue without question that Cooper's European experience
not only sharpened his appreciation of landscape but gave
him an aesthetic that enabled him to introduce a clarity of
overall concept, composition, and detail that is lacking in his
earlier generalized landscapes, whether real, ideal, or
allegorical. The description of Prairie Round in *The Oak
Openings* may be a lapse from his usual success, but even it
suggests, to put the matter crudely, that he knows much better
than he once did the kinds of pictures he is trying to compose.
Glimmerglass in *The Deerslayer* is not the Glimmerglass of
The Pioneers, and the difference is due less to the time settings
than to the visual discipline that the author has acquired in the
interval. And it is inconceivable that the opening chapters of
Wyandotté could have been written prior to Cooper's Euro-
pean sojourn.

II

The evidence in the preceding chapters speaks convincingly, I trust, for the range and genuineness of Cooper's knowledge of the aesthetics of landscape. It has been my intention, however, to lay the groundwork for another suggestion, and that is that following his return from Europe Cooper's method of conceiving his settings was so strongly influenced by his aesthetic experience that when he looked upon his native landscape for the purposes of fiction he shaped what he saw to what he already knew. This concept of image-making, argued with such scholarly persuasiveness by E. H. Gombrich in his influential *Art and Illusion*, lays great stress on the expectation—or, in psychological terms, the "mental set"—with which the artist, as well as his audience, views his subject. We see what we know. What we call "seeing," Gombrich argues, is to a remarkable degree determined by the habits and expectations generated by a particular culture. The artist begins with a familiar schema—what he knows—and modifies it by a process of "matching" with what he sees—or, to be more exact, with what he thinks he sees. It is Gombrich's central thesis that "making" precedes "matching," that "before the artist ever wanted to match the sights of the visible world he wanted to create things in their own right." But he "has to know and construct a scheme before he can adjust it to the needs of portrayal."[7]

It follows, therefore, that art cannot be an imitation of reality, a reproduction of what the senses presumably "see" in nature; it is the process, rather, by which the motif the artist wishes to render is first brought within the context of a schema which, if the artist is sensitive and enterprising, will then be modified with reference to what his senses tell him is

[7] E. H. Gombrich *Art and Illusion*, 3d ed. (London: Phaidon Press, 1968), p. 99.

"out there." In a primary sense, then, art is the product of art; it originates in conventions and makes its advances only by virtue of accepting the schema and then working from it, by a process of differentiation and adjustment, toward the "new" image, which will be the accommodation of the schema to the observed reality. "To read the visible world as art," says Gombrich, ". . . we must mobilize our memories and experiences of pictures we have seen and test the motif again by projecting them tentatively onto a framed view."[8]

It was in the course of development of landscape painting, in which the act of seeing raised so many vexing problems, that the theory of perception and creation was first discovered and articulated. And it is here too, in the history of landscape art over the last four centuries, that we may find the clearest illustrations of J. J. Gibson's contention that "the visual field is the product of the chronic habit of civilized man of seeing the world as picture" and that "so far from being the basis, it is a kind of *alternative* to ordinary perception."[9] Gombrich has demonstrated how markedly Constable, for all his insistence that the superior artist discovers, in the artist's words, "by a close observation of nature . . . qualities existing in her, which have never been portrayed before, and thus forms a style which is original,"[10] could follow the practice of merely imitative artists and succumb to the idiom of predecessors like Gaspard Poussin and Gainsborough. Without the magisterial example of Claude, moreover, the English amateur, insists Gombrich, "would never have thought of discovering 'picturesque motifs' in his native scenery."[11] The artist, "no less than the writer, needs a vocabulary before he can embark on a 'copy' of reality," and Gombrich illustrates this point by com-

[8] Ibid., p. 265.
[9] Quoted in Gombrich, *Art and Illusion*, p. 277.
[10] Gombrich, *Art and Illusion*, p. 150.
[11] Ibid, p. 158.

paring a charming view of Derwentwater, executed in brush and ink by the Chinese writer and painter, Chiang Yee (better known to western audiences as the Silent Traveller), with "a typical 'picturesque' rendering" of the same view from the Romantic period to indicate how the former must adapt the idiom of Chinese landscape painting to "the unfamiliar task of topographical portrayal in the Western sense." We see, he observes,

> . . . how the relatively rigid vocabulary of the Chinese tradition acts as a selective screen which admits only the features for which the schemata exists. The artist will be attracted by motifs which can be rendered in his idiom. As he scans the landscape, the sights which can be matched successfully with the schemata he has learned, will leap forward as centres of attention. The style, like the medium, creates a mental set which makes the artist look for certain aspects in the scene around him that he can render. Painting is an activity, and the artist will therefore tend to see what he paints rather than to paint what he sees.[12]

It is not difficult to apply this theory of the nature and history of artistic perception to the mode by which Cooper's visual imagination is expressed in his fiction. We can surmise that even before his seven-year residence in Europe his way of looking at landscape was conditioned to some degree by both ideal and topographical landscape art and poetry, by contemporary books of travel, and to a less important degree by the prose romance, of which Scott was the current exemplar, in which physical setting as we know it was in its earliest stage of definition. In the romances preceding *The Last of the Mohicans*, he has mastered the prospect view, whether for purposes of ideal or topographical landscape, and, as has been frequently noted, he has adapted the motifs of Dutch and

[12] Ibid, p. 73.

Flemish genre painting for the pastoral episodes that characterize *The Pioneers* (as they will the later *Satanstoe*). At this early stage his landscapes are as generalized as those of Scott, and in fact it is only with *The Last of the Mohicans* that he begins to explore the range and possibilities of the picturesque (or what he called then the "romantic") vision.

But what will be apparent following Cooper's return from Europe is that the knowledge he acquired there, through the direct apprehension of landscape as well as through the mediation of books, pictures, and conversation, altered permanently his way of looking at his native scenery. His recollection in the Introduction to *The Heidenmauer* of a journey up the Rhine, during which he was made constantly aware of "how intimate is the association between the poetry of nature and that of art," suggests the direction his education took. The simplest way of putting it would be to say that he returned to Cooperstown with his head full of pictures and that they were pictures in which art modified nature in accordance with the dictates of taste (a natural faculty, Cooper believed with his era, but one that could be cultivated by experience). From now on, his landscapes, whether presented directly or through the eyes of his characters, will to a marked degree represent the attempt to bring the characteristic motifs of American scenery into the context of schemata acquired abroad and to revise them by that process of "matching" which Gombrich describes as integral to the realization of the new image.

One aspect of this attempt we have noted before. The characters in *Homeward Bound* and *Home as Found*, confronted after a long absence by their native scene, constantly refer what they see to what their recent experience of European landscape has taught them. "Fresh from the bolder landscapes of southern Italy," the characters in the former novel debate the aesthetic qualities of the picture the Bay of

New York presents as they approach the Battery. In the light of their Italian memories, the villages and villas that line the shore are "meagre," the smaller vessels "less picturesque," particularly, in Eve Effingham's opinion, because their tall spars are out of keeping with "the tame and level coast, river banks, and the formation of the country in general." Even granting that "her countrymen were almost ignorant of the art of landscape gardening," as she has been informed, Eve is disappointed by the Battery, because "although beautifully placed . . . it had neither the extent and magnificence of a park nor the embellishments and luxurious shades of a garden." Travelling up the Hudson (in *Home as Found*), the Effingham party is better pleased, and consequently in a mood of revived patriotism. Their comments echo Cooper's tribute to that noble river in *Notions of the Americans* with the difference that the author has imposed his own newly acquired connoisseurship on their vision. When Mr. Effingham remarks that the Highlands seem "less imposing than formerly" and that the scenery appears "fine" but hardly "grand," his brother replies: "You never uttered a juster opinion, Ned, though after your eye loses some of the forms of the Swiss and Italian lakes, and the shores of Italy, you will think better of these. The Highlands are remarkable for their surprises, rather than for their grandeur, as we shall presently see." Eve is inclined toward her uncle's persuasion. Remarking that the view of a noble headland is "Italian," she pays it the ultimate compliment: "One seldom sees a finer or softer outline on the shores of the Mediterranean." Later, when the party is gathered on a height commanding a view of the valley of the Susquehanna with Templeton and its lake, "a *coup d'oeil* that was almost Swiss in character and beauty," Eve tries to envisage the shore of the lake lined with villas, "church-towers raising their dark heads among these hills; each mountain crowned with a castle or a crumbling ruin, and all the other

accessories of an old state of society." With her recently acquired zest for associations, she is excited to find a giant pine, a hundred feet tall, which must have existed when William the Conqueror invaded England. "Here, then," she exclaims, "is at last an American antiquity."

All this is "matching" with a vengeance, the application of a new idiom and vocabulary to a once familiar landscape in order to redefine its aesthetic character. But another example will better illustrate how Cooper employs the schema to develop a new image. Successively in *Home as Found*, *The Redskins*, and *The Oak Openings* the European park provides the schema by which he tries to define his landscape—that is, by which he organizes the elements of a familiar scene within a new context. Speaking, in *The Redskins*, of "the pieces of woodland that are almost invariably attached to every American farm, lending to the landscape a relief and beauty that are usually wanting to the views of older countries," he singles out this "peculiarity" as the one that imparts to "the views of the republic . . . so much of the character of the park scenery when seen at a distance, that excludes the blemishes of want of finish, and the coarser appliances of husbandry." Through the agency of his narrator in the same novel, Hugh Littlepage, who is revisiting Ravensnest, Cooper begins with the schema and then by a process of matching tries to accommodate it to the native reality:

Many people would have called the extensive lawns which surrounded my paternal abode a park, but it never bore that name with us. They were too large for a paddock, and might very well have come under the former appelation; but, as deer, or animals of any sort, except those that are domestic, had never been kept within it, the name had not been used. We called them the grounds—a term which applies equally to large and small enclosures of this

nature—while the broad expanse of verdure which lies directly under the windows goes by the name of the lawn.

In *Home as Found*, in a passage previously cited, the Effingham party is looking down from a height on Templeton and the valley of the Susquehanna:

Hundreds of feet beneath them, directly in front, and stretching leagues to the right, was a lake embedded in woods and hills. On the side next the travellers a fringe of forest broke the line of water; tree-tops that intercepted the view of the shores; and on the other, high broken hills, or low mountains rather, that were covered with farms, beautifully relieved by patches of wood, in a way to resemble the scenery of a vast park or royal pleasure ground, limited the landscape. High valleys lay among these uplands, and in every direction comfortable dwellings dotted the fields. The dark hues of the evergreens, with which all the heights near the water were shaded, were in soft contrast to the livelier green of the other foliage, while the meadows and pastures were luxuriant with a verdure unsurpassed by that of England. Bays and points added to the exquisite outline of the glassy lake on this shore, while one of the former withdrew towards the northwest, in a way to leave the eye doubtful whether it was the termination of the transparent sheet or not. Towards the south, bold, varied, but cultivated hills, also bounded the view, all teeming with the fruits of human labor, and yet all relieved by pieces of wood in the way already mentioned, so as to give the entire region the character of park scenery.

I have reproduced the passage at length to indicate not only the presence of a schema but, once again, Cooper's awareness of the values, characteristic of the picturesque gardener's art, of *contrast* ("the dark hues of the evergreens . . . in soft contrast to the livelier green of the other foliage," the "glassy lake" bordered by high, broken hills, the farms "beautifully

relieved by patches of wood"), *variety* ("bold, varied, but
cultivated hills"), *irregularity* (the "bays and points" which
aid the "exquisite outline" of the lake), *intricacy* (defined by
Uvedale Price as "that disposition of objects, which, by a par-
tial and uncertain concealment, excites and nourishes
curiosity"), and the *setting of bounds* to the view ("limited the
landscape," "bounded the view").

And finally, when he comes to describe Prairie Round in the
passage from *The Oak Openings* reproduced a few pages
back, Cooper adopts a stratagem that illustrates more clearly
perhaps than the preceding examples the "making and
matching" process. Apparently he cannot envisage the
scene—cannot "see" it, in effect—until the schema has played
its role in defining it. The prairie—this oak opening in the gen-
tle Michigan wilderness—can be conceived and represented
only as a European park, from which the human and domestic
features have vanished, leaving the "verdant sward" and the
"glades, vistas, irregular lawns, and woods" that seem to have
been designed by "consummate art" rather than by "the free
hand of nature."

Now, compare these park-like landscapes from the later
works, but especially the one from *Home as Found*, with an
earlier landscape in *Notions of the Americans*, cited but not
reproduced in another context in Chapter I (p. 23):

> The view was limited to what lay in advance of a line drawn
> nearly east and west, the adjacent mountains presenting
> obstacles to our vision, further south. It was completely an
> American scene, embracing all that admixture of civiliza-
> tion, and of the forest, of the works of man, and of the
> reign of nature, that one can so easily imagine to belong to
> this country.
>
> There was perhaps an equal distribution of field and
> forest. The latter term is not, however, the best, since it was
> a constant succession of open land and of wood, in propor-

tions which, without being exactly, were surprisingly equal. You have stood upon a height and looked down upon a fertile French plain, over which agriculture has been conducted on a scale a little larger than common. You may remember the divisions formed by the hues of the grains of the vineyards, and of the grasses, which give to the whole an air so chequered and remarkable. Now, by extending the view to the size I have named, and enlarging these chequered spots to a corresponding scale, you get a tolerably accurate idea of what I would describe. The dark green shadows are produced by the foliage of a wood, reserved, perhaps, for the use of half a dozen farms, and lying in a body, (some common objection to culture influencing that number of proprietors to select adjacent ground for their reservations), and the fields of golden yellow, or of various shades and hues, are produced by the open fields. The distance diminishes the objects to the eye, and brings the several parts so much in union, as to lend to the whole the variegated aspect of the sort of plain just mentioned. The natural river which divides this glorious panorama in nearly two equal parts, with its artificial rival [a canal], and the sweet meadows that border its banks, were concealed beneath the brow of the last precipitous descent. But countless farmhouses, with their capacious outbuildings, dotted the fields, like indicated spots on a crowded map. From those in the near view rose the light vapoury summer smoke. The fields were alive with herds, and with numberless and nearly imperceptible white atoms, which, but for their motion, it would not have been easy to imagine flocks. In the distance, though these more minute objects were lost, habitations, barns, and pyramids of hay and of grain, could be distinguished until the power of vision failed. Immediately at our feet, at the distance of a few miles, lay a wide, rich terrace, intersected with roads that were bordered, as usual, with scattered farm buildings, surrounded by their granaries and barns. Near its centre a

cluster of buildings assumed the air of a hamlet. From
among these roofs rose the spire of a country church. I was
told that a multitude of villages lay within the limits of the
view; but as they were generally placed near some stream,
for the advantages of its water power, the uneven forma-
tion of the land hid them from our sight.[13]

The locale from which this view in *Notions* is taken is in the
neighborhood of that in the *Home as Found* prospect. The
elements of the two landscapes are virtually the same, except
that one valley features a lake, the other a river. But in contrast
to the landscape in the novel, the one in *Notions* is blurred and
messy, the picturesque qualities are absent, and the park
analogy, which determines the frame and general character of
the later landscape, is missing. The unity of the composition,
such as it is, is achieved not through a governing schema but
almost entirely through perspective. This is not to say, of
course, that Cooper finds a new value in the landscape by vir-
tue of its old world association or that what is implied by the
altered character of the landscape is a change in the viewer's
social philosophy. The nature of Cooper's visual perception
does not necessarily change with his increasing conservatism;
his aesthetic development, as distinct from his choice of
themes and plots, cannot be correlated to any precise degree
with the development of his social thought. To argue
otherwise, I believe, is to discount the independent and often
sporadic nature of aesthetic insights as well as the particular
ends which they serve. Was Cooper drawn to the English gar-
den merely because it embodied the preference of his era and
was his natural legacy from the mother country, or can we say
that he was also, like Humphry Repton, conscious of the im-
pulse toward freedom it represented, as opposed to the
"despotic" restraint symbolized by the formal garden? These

[13] Cooper, *Notions of the Americans*, I: 332–334.

are questions which can be legitimately raised but the answers
to which cannot be final or satisfactory because they ignore
the aesthetic question. Cooper's answers to the aesthetic ques-
tion may illuminate his choices at a more conscious level,
determined, more obviously, by the nature of his materials, his
medium, and the necessities of his plot and theme.

To what degree the art of landscape became in Cooper's
hands what Gombrich calls "the innovators instrument for
probing reality"[14] is a question not easily settled. Whether or
not he possessed in the truest sense a radical visual imagina-
tion, he did create a new convention through which his coun-
trymen could view their primitive landscape. The clarity with
which he projects his landscapes owes much to the con-
noisseur's eye, and that in turn owes much to the European
experience which sharpened and defined his sense of
landscape, provided him with a wider and more exact idiom,
and thus promoted his awareness of the visual and dramatic
possibilities of the American frontier setting. There is no es-
caping the fact that, like Balzac and Parkman, what we are
most apt to retain from Cooper is a series of magnificent
tableaus in which setting may enhance the dramatic moment,
as in an historical painting, but carries less of the symbolic im-
port that we find in the tableaus of Hawthorne or Faulkner.
Like Conrad, Cooper wants to make us *see*, not so much
through the Polish novelist's impressionistic surrounding vi-
sion of form and color, however, but directly, fully, frequently
almost literally, and always precisely. And to achieve this end
he drew on a set of conventions derived from his experience of
landscape art and landscape gardening which, though con-
troversial and even somewhat anachronistic, enabled him to
preserve in unforgettable lineaments the image of our lost
wilderness and, as some would have it, our lost youth.

[14] Gombrich, *Art and Illusion*, p. 274.

APPENDIX

Cooper and His Illustrators

It has not been one of the purposes of this essay to consider at any length the relation of Cooper's visual imagination to that of his artistic contemporaries, illustrators as well as painters, who reproduced scenes from his romances. I would suggest, however, that their contribution has less to do with the appreciation of Cooper's own mode of perception and techniques of description than may be generally supposed. The illustrators can be excused; their preoccupation is with illustrative crises—moments (as in Felix Darley's drawings) of danger, death, parting, reconciliation, attack, discovery, with occasionally a milder episode of sentimental import such as courtship or mourning. Their whole business is with the foreground action, and their concern with the physical setting or with the relation of the action to its background is minimal or nonexistent. There is much amusement to be had in examining the illustrations in foreign editions of Cooper, but the experience has little to do with understanding the nature of Cooper's intentions, and the amusement depends on our appreciation of national physiognomy, dress, idiosyncracies, and the like. For example, the vignettes executed by the brothers Johannot for an early (1827–29) French collected edition are delightful for their conception of frontier costume and their preoccupation with the feminine sensibility.[1] The characters

[1] The edition is described in Robert E. Spiller and Philip C. Blackburn, *A Descriptive Bibliography of the Writings of James Fenimore Cooper*

FIGURE 1. *Illustration by Tony Johannot for* The Pioneers.
*Reproduced courtesy of the Huntington Library, San
Marino, California.*

(New York: R. R. Bowker Co., 1934), p. 181. The original drawings by
Alfred and Tony Johannot are in the Huntington Library, San Marino,
California.

of both sexes are cumbersomely overdressed, in what appears to be formal court attire; there is a predominance of the grotesque, in the manner of Dickens's early illustrators, in the rendering of the male physiognomy (Natty Bumppo has a disproportionate, dome-like head with bulging brow); and the female characters, in attitudes of pleading, pining, fainting, grieving, and confiding, are much more in evidence than in the English and American illustrations or than Cooper's emphasis warrants. (Fig. 1) The frontispieces done by various illustrators for the English Bentley Standard Novels edition are hardly less rewarding; their special flavor may be suggested by the representation of Natty Bumppo mourning at Chingachgook's grave—the old hunter in a half-reclining posture before a neoclassical cenotaph with urn, backed by weeping willows, tracing out the epitaph with the index finger of his left hand.[2]

But even the American, Darley, whose illustrations exhibit a greater fidelity to realistic detail and are notable for their vigor of conception, could frequently have profited from a closer attention to Cooper's text. For the single combat between Hard-Heart and Mahtoree in Chapter XXX of *The Prairie* Cooper devised one of his most carefully framed and thematically unified scenes. The encounter takes place on a narrow sandbar in the middle of a shallow prairie stream. The Pawnee and Teton partisans of the combatants are ranged along opposite banks. The setting and the disposition of the figures are so clear in their visual definition that an illustrator might understandably have seized on Cooper's solution. But in Darley's version the contest takes place on the open prairie, with a half dozen unidentified horsemen in the middle distance, and with a mountain peak looming dimly in the background. Cooper's picture emphasizes the tension between

[2] James Fenimore Cooper, *The Pioneers* (London: Richard Bentley, 1836).

FIGURE 2. *Illustration by F. O. C. Darley for* The Prairie.

the warriors' supporters, the fragility of the truce, and the isolation of the combatants. (Fig. 2) It capitalizes on that close circumscription of space that Poe, rightly or wrongly, held indispensable to intensity of effect. Darley's conception, even if we allow for the limitations of his medium and his concentration on the foreground action, must strike us as misleading and somewhat banal in comparison.[3]

[3] Darley's illustration may be found in *The Cooper Vignettes, From Drawings by F. O. C. Darley* (New York: James G. Gregory, 1862), p. 146.

The point would not be worth raising were it not that the same disregard of the text is manifest in so many other illustrations for Cooper. We may take for example an illustration in which the artist has been compelled by the nature of the scene he is representing to strike a balance between the figures in the foreground and the background vista: the scene on which *The Pathfinder* opens, reproduced at the beginning of Chapter IV of this essay. As Cooper conceives it, the effect is one of sublimity, for its two main elements are the interminable forest, stretching towards Lake Ontario, and the thirty-foot-high pile of uprooted trees, whose destruction has opened the wind-row in which the travellers pause to take their bearings. Almost nothing of Cooper's intentions survives the treatment of this scene in the engraving taken from the painting of the Irish-born landscapist, James Hamilton (Fig. 3), who obscures the vista by the size and disposition of his foreground trees, reduces the pile of blasted trunks to a single unobtrusive specimen resembling a stranded octopus, and, contrary to the text, introduces a meandering river at the foot of the declivity.[4] The result is that his version has almost no affinity with Cooper's, and one would do better to turn to a prospect landscape that has no connection with Cooper's fiction, Thomas Cole's *The Ox Bow*, (Fig. 4) to find an approximate reproduction of the mood and design of this *Pathfinder* landscape.

Hamilton, like Cole, is a painter rather than an illustrator; like Cole, though less consistently, he subordinates the human figures to the general effect of the landscape. (Compare, for

[4] The engraving by J. Duthie from Hamilton's original may be found opposite p. 8 in the Red Rover Extra-Illustrated Edition of *The Pathfinder* (New York: G. P. Putnam's Sons, n.d.). Little is known about Hamilton beyond the facts recorded in John T. N. Baur, "A Romantic Impressionist: James Hamilton," *Brooklyn Museum Bulletin*, 12 (1951): 1–9.

FIGURE 3. *Illustration by James Hamilton for* The Pathfinder.

FIGURE 4. *Thomas Cole, The Oxbow, oil on canvas. Reproduced courtesy of The Metropolitan Museum of Art, New York City.*

example, his treatment of the wreck of the Ariel [*The Pilot*] with Darley's (Figs. 5 and 6): the one emphasizing darkness, lightning, the tumult of giant waves, on the crest of which the stricken ship looms in the background, and, in the foreground, the capsized longboat with the tiny figures of the crew spilling into the water; the other—and it is one of Darley's finest drawings—merely suggesting the catastrophe in the figure of Long Tom on the wreck of the Ariel, his right leg anchoring him to the bowsprit, his left hand grasping a taut line, and below him the ship's figurehead, with bowed head and hands clasped across her breast.)[5] In general, it can be argued that Hamilton in his illustrations from Cooper has more regard for the romancer's purposes than does Cole; but both are predisposed to employ the text as a point of departure for their own readings of nature, exhibiting her in the moods that solicit their own imaginations and that may be quite foreign to the mood and intentions of the narrative. The distant human figures in Cole's two paintings from *The Last of the Mohicans, Cora at the Feet of Tamenund* (which exists in two versions) and *The Death of Cora*, all but lost in the grandeur of the natural setting and subordinated in the design to the curious rock formations to which Cole, like Cooper, was addicted, testify to the insignificance of the human drama in terms both of the immediate conception and of the cosmic scale. This is, of course, characteristic of the tradition that Cole inherited, but the mood of sublimity that dominates so many of his early landscapes, with its testimony to the awesome power of the Creator, is not the characteristic mood of Cooper's forest romances (as it is, more appropriately, of *The Prairie*). Cole's sublime landscapes, often depicting subjects

[5] Hamilton's version forms the frontispiece of the Red Rover Extra-Illustrated Edition of *The Pilot* (New York: G. P. Putnam's Sons, n.d.); Darley's may be found in *The Cooper Vignettes*.

FIGURE 5. *Illustration by James Hamilton for* The Pilot.

FIGURE 6. *Illustration by F. O. C. Darley for* The Pilot.

drawn from the Bible and classical mythology, such as *St. John Preaching in the Wilderness*, *The Expulsion from the Garden of Eden*, or *Prometheus Bound*, are closer in spirit and execution to the landscapes of Chateaubriand's *Atala*—just as his Italian and Sicilian landscapes recall those of *René*—than they are to Cooper's landscapes. It is in his quieter topographical views of mountain, lake, and forest scenery in the Hudson Valley, the Catskills, or the White Mountains, that Cole's landscapes come closest to Cooper's. Here the painter, like the romancer, can utilize nature's deformities—chimney rocks, balancing rocks, natural arches, jutting mountain crags and terraces—as motifs in his compositions; but here he is also compelled by the milder features of the American scenery to restrain his effects to what was appropriate to the picturesque convention. Generally, however, Cole's treatment of landscape reflects an even more heightened romanticism than Cooper's, perhaps for the same reason that the letters he wrote home from abroad reflect a disposition, the opposite of Cooper's, to maintain the superiority of American natural scenery to that of Europe.

Index